CAT LADY
EMBROIDERY

© 2018 Quarto Publishing Group USA Inc.

First published in 2018 by Creative Publishing international, an imprint of The Quarto Group, 401 Second Avenue North, Suite 310, Minneapolis, MN 55401, USA.
T (612) 344-8100 F (612) 344-8692 QuartoKnows.com

NEKO-DARAKE SHISHU 380
Copyright ©2016 applemints
Originally published in Japanese language by applemints. All rights reserved.
No part of this book may be reproduced in any form without written permission from the original proprietor.

English language translation & production by World Book Media, LLC
Email: info@worldbookmedia.com
English translation rights arranged with E&G Creates Co., Ltd. through Timo Associates, Inc., Tokyo

Creative Publishing international titles are also available at discount for retail, wholesale, promotional, and bulk purchase. For details, contact the Special Sales Manager by email at specialsales@quarto.com or by mail at The Quarto Group, Attn: Special Sales Manager, 401 Second Avenue North, Suite 310, Minneapolis, MN 55401, USA.

10 9 8 7 6 5 4 3 2 1

ISBN: 978-1-58923-964-7

Library of Congress Cataloging-in-Publication Data available

Printed in China

CAT LADY EMBROIDERY

380 Ways to Stitch a Cat

APPLEMINTS

Creative Publishing international

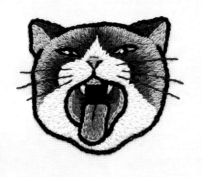
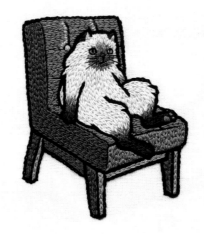
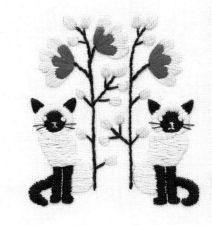
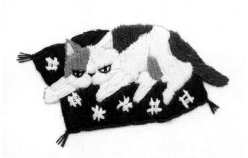
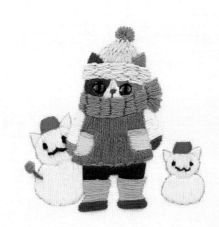
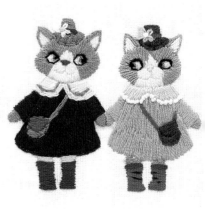
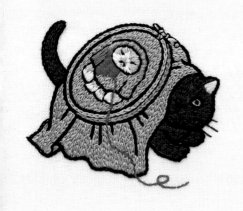
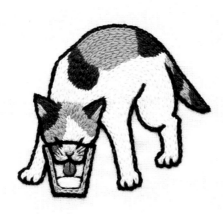
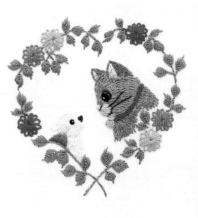

CONTENTS

CURIOUS CATS

instructions: pages 56–59
design + embroidery: martinachakko (Hiroko Sonobe)

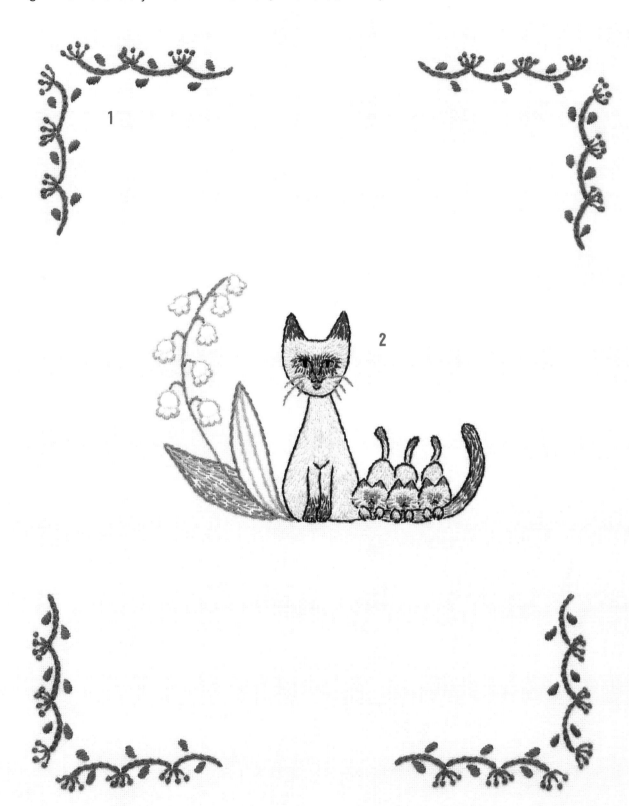

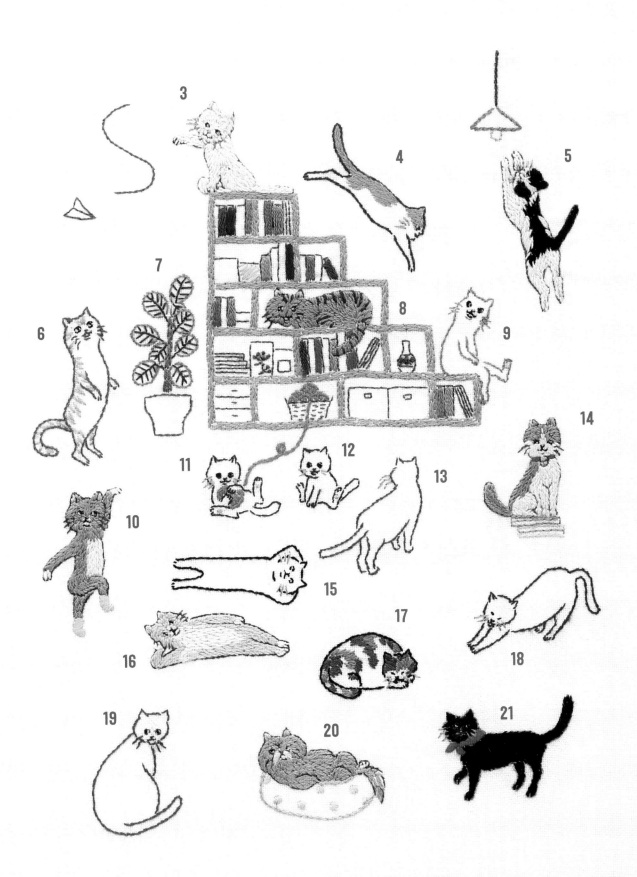

FELINE FACES

instructions: pages 60–63
design + embroidery: saoliica

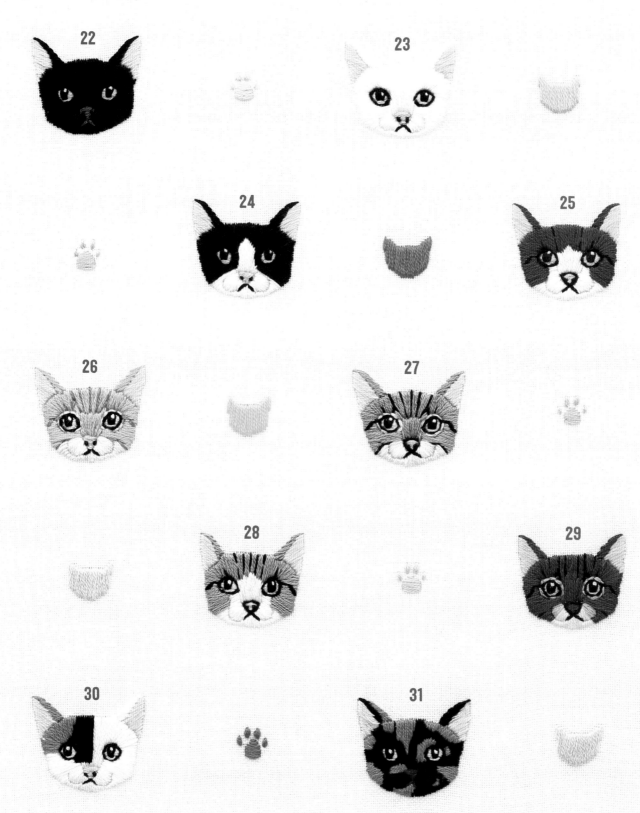

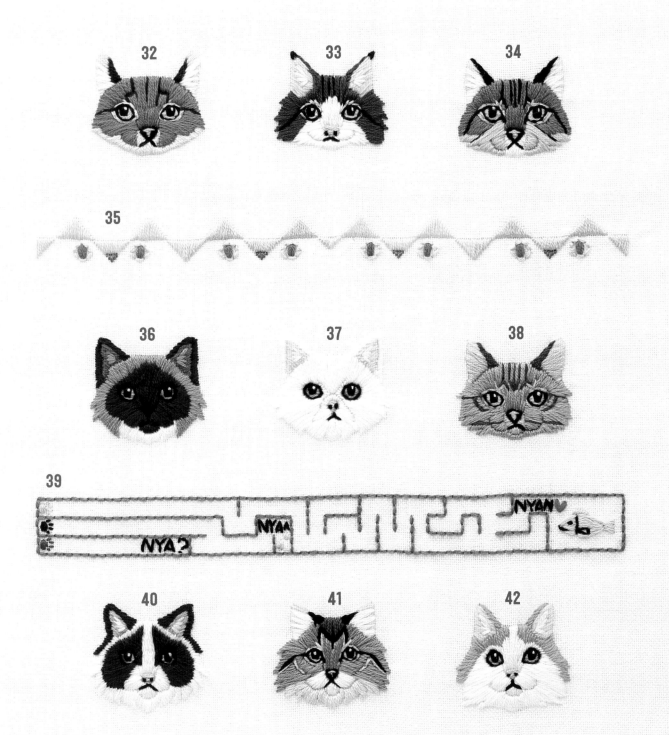

HEADS & TAILS

instructions: pages 64–67
design + embroidery: saoliica

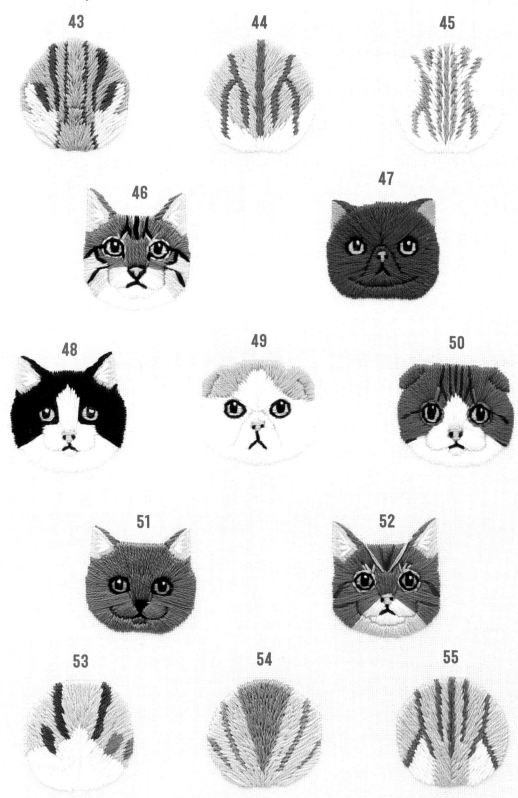

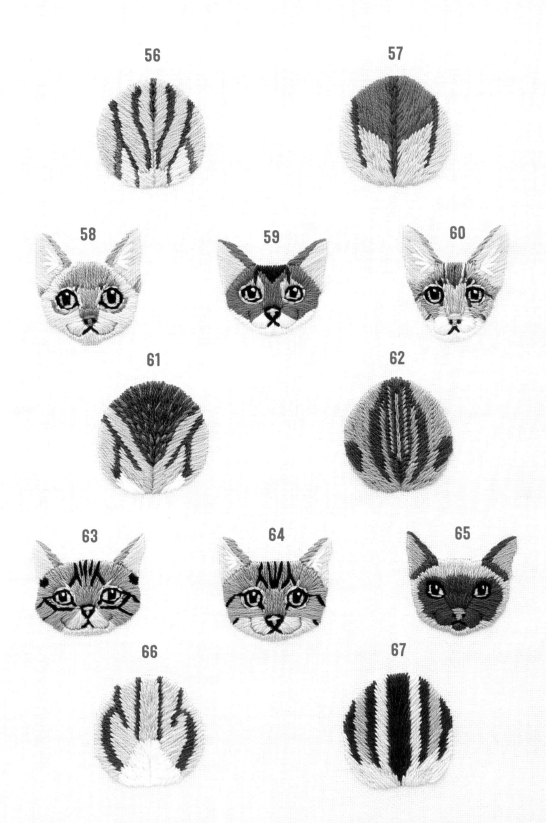

56

57

58

59

60

61

62

63

64

65

66

67

11

CAT ANTICS

instructions: pages 68–71
design + embroidery: pocorute pocochiru

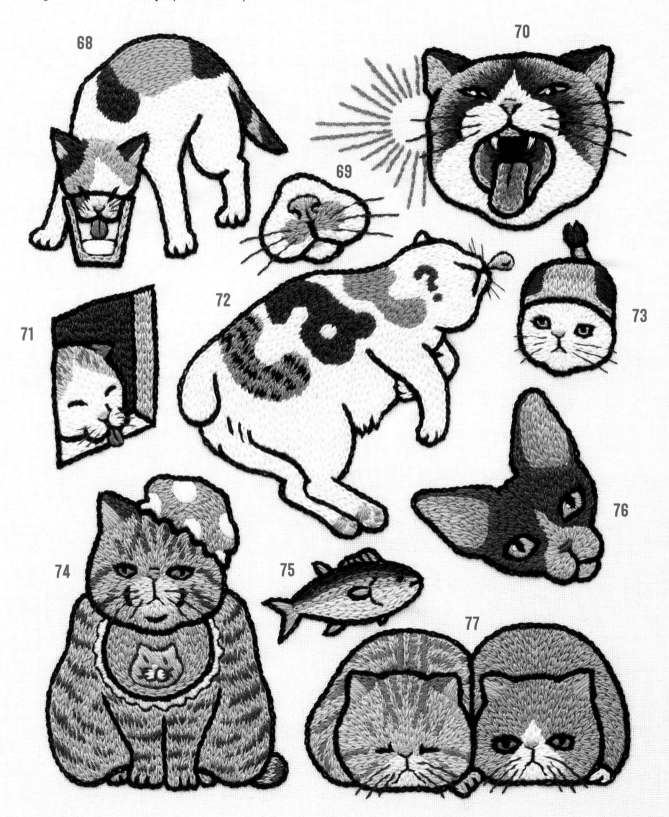

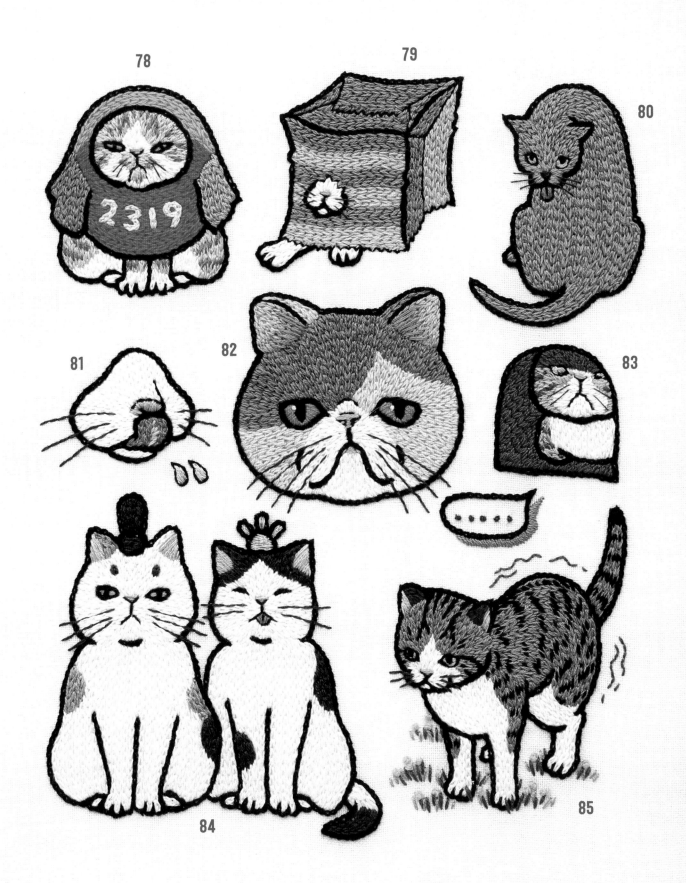

CHATTY CATS

instructions: pages 72–75
design + embroidery: pocorute pocochiru

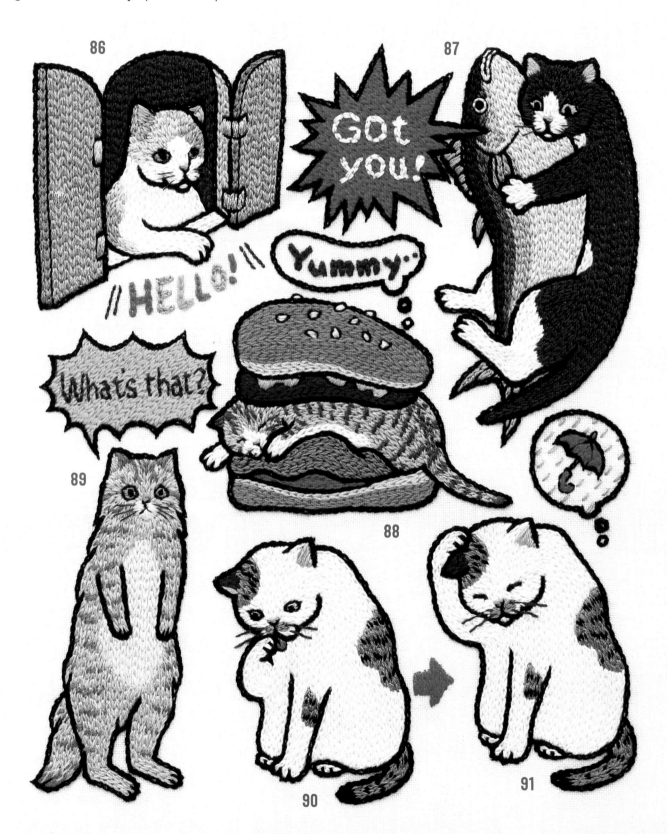

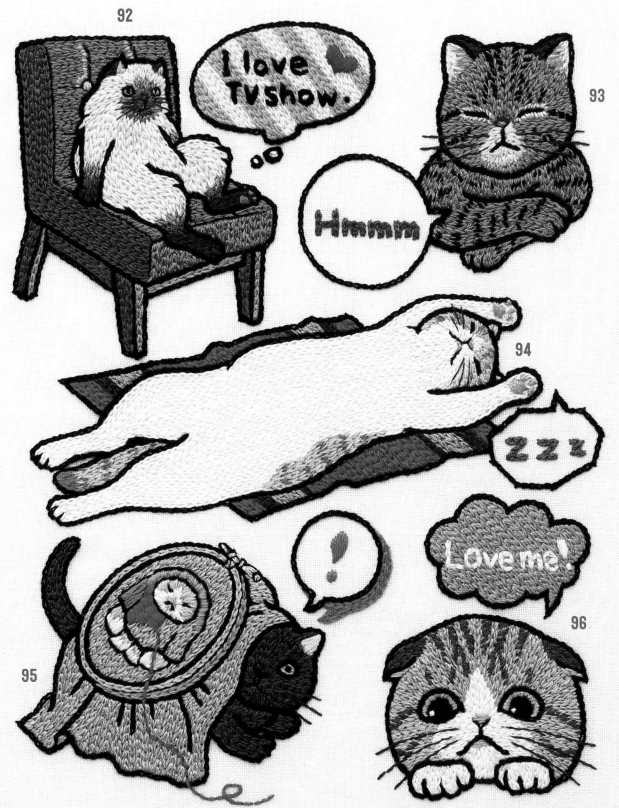

HOLIDAY CATS

instructions: pages 76–79
design + embroidery: siesta (Fumiko Saito)

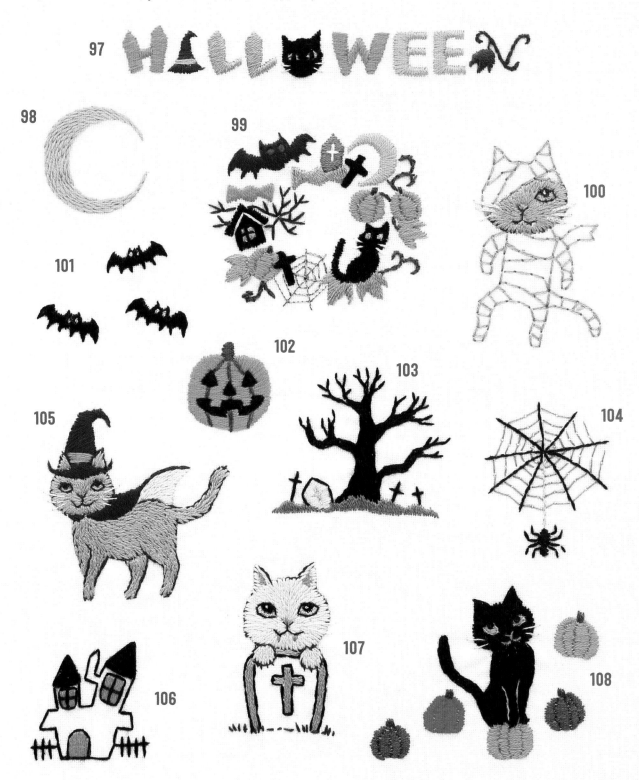

97

98

99

100

101

102

103

104

105

106

107

108

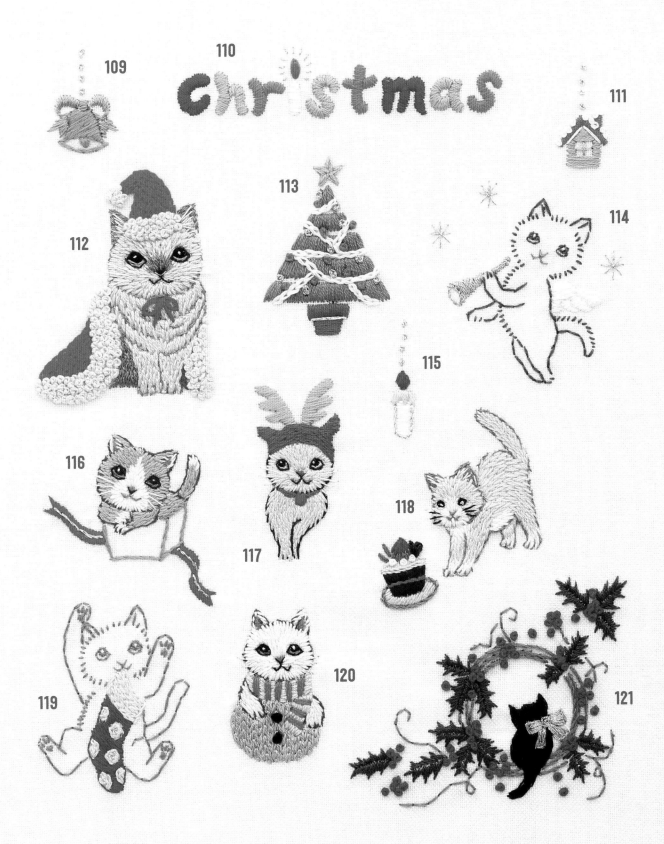

109

110 christmas

111

112

113

114

115

116

117

118

119

120

121

FLORA & FAUNA FELINES

instructions: pages 80–83
design + embroidery: annas

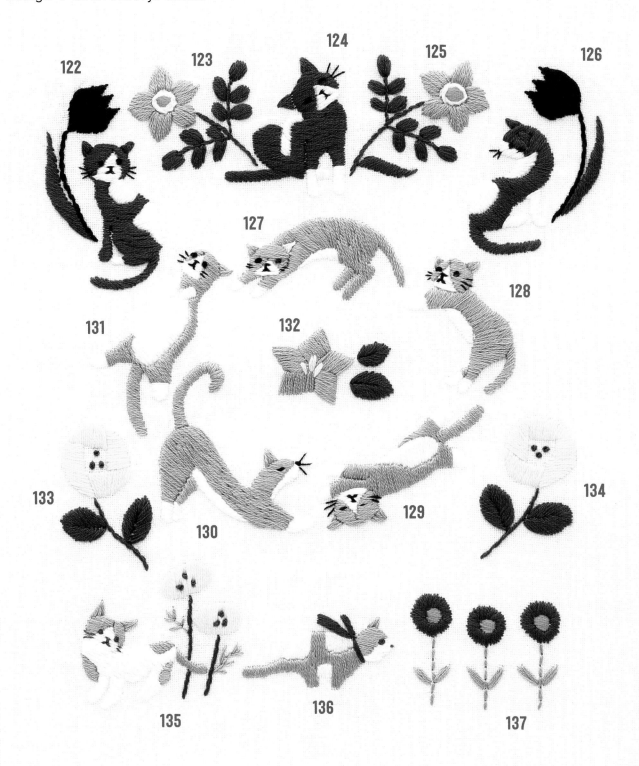

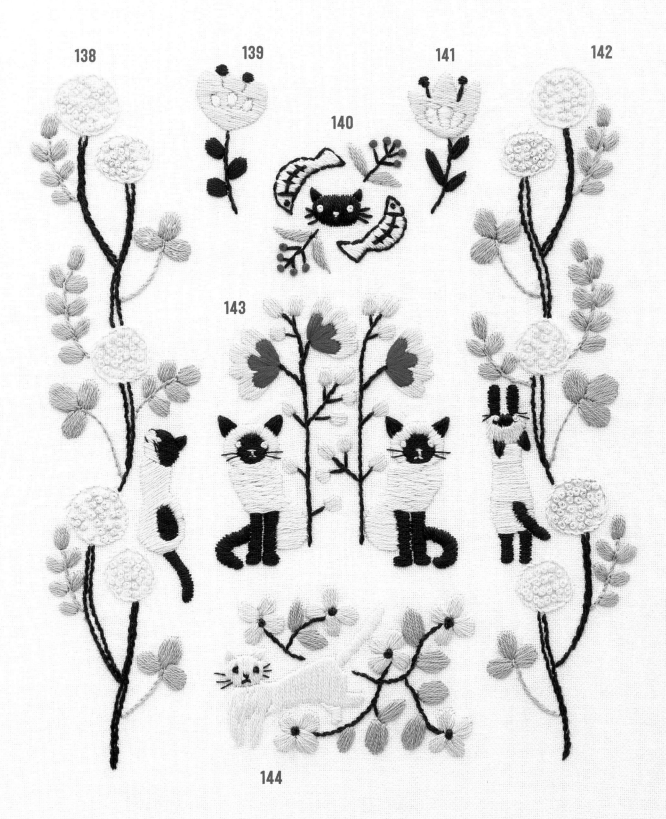

138 139 140 141 142 143 144

PAMPERED PUSSYCATS

instructions: pages 84–87
design + embroidery: Kayoko Terasawa

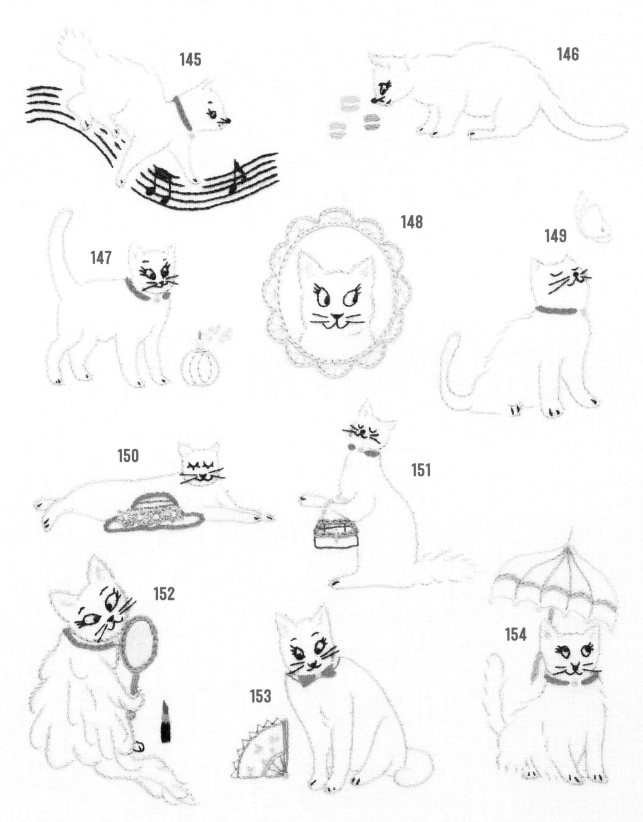

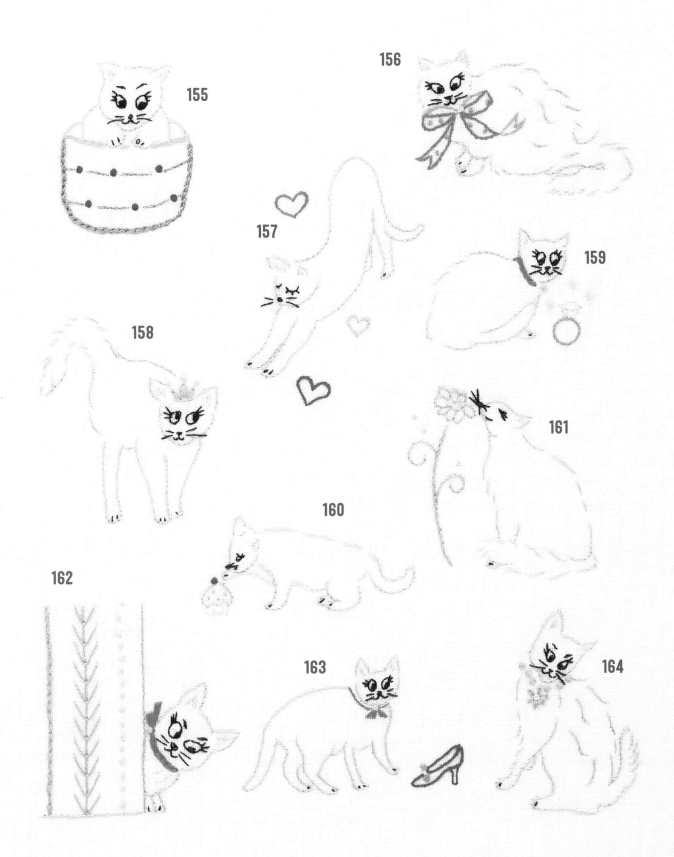

155

156

157

158

159

160

161

162

163

164

EVERYDAY SHENANIGANS

instructions: pages 88–91
design + embroidery: momolunch

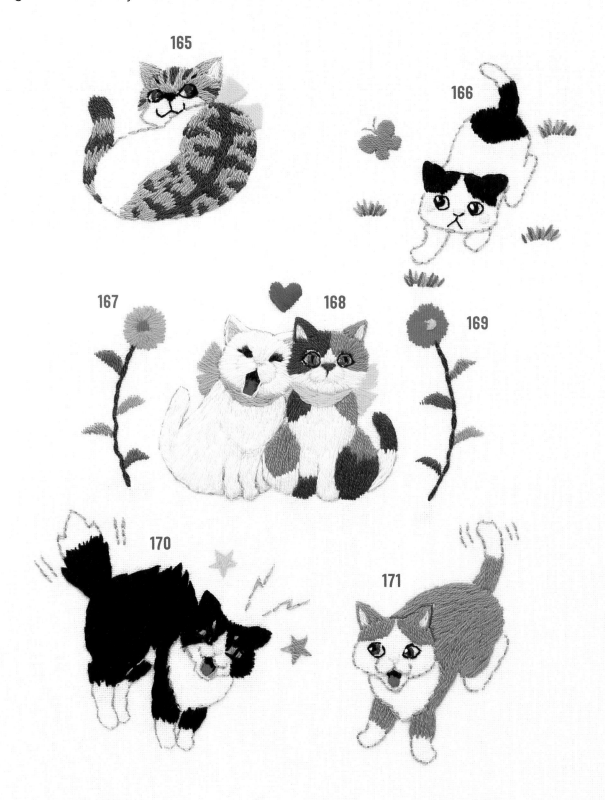

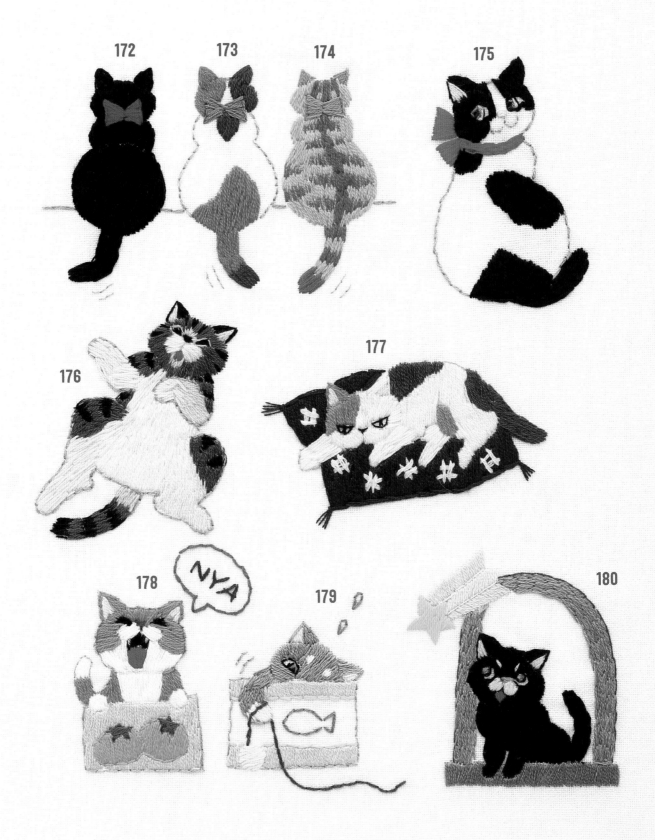

CAT CHARACTERS

instructions: pages 92–95
design + embroidery: momolunch

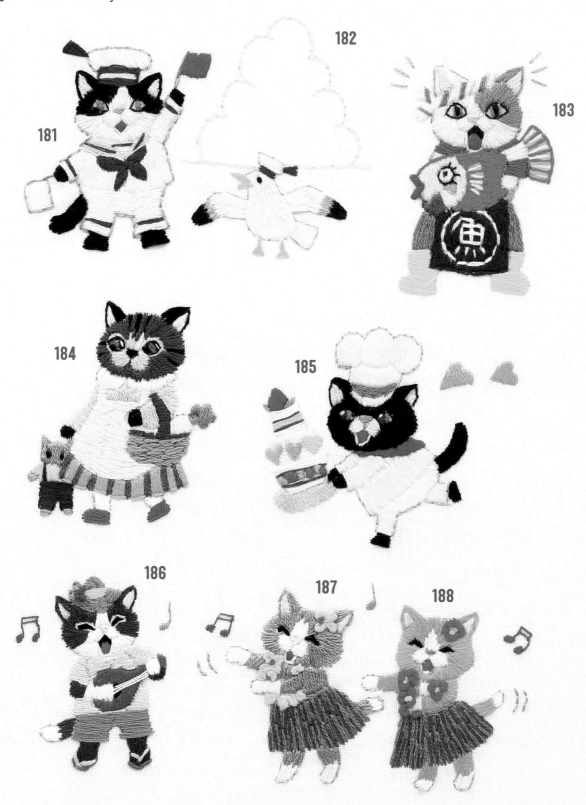

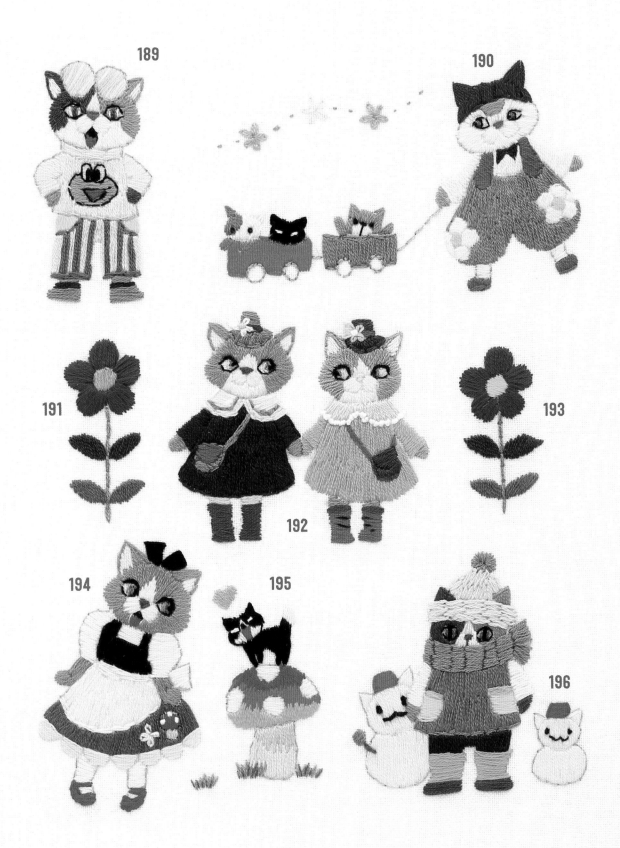

189

190

191

192

193

194

195

196

FAST FRIENDS

instructions: pages 96–99
design + embroidery: Tomoko Watabe

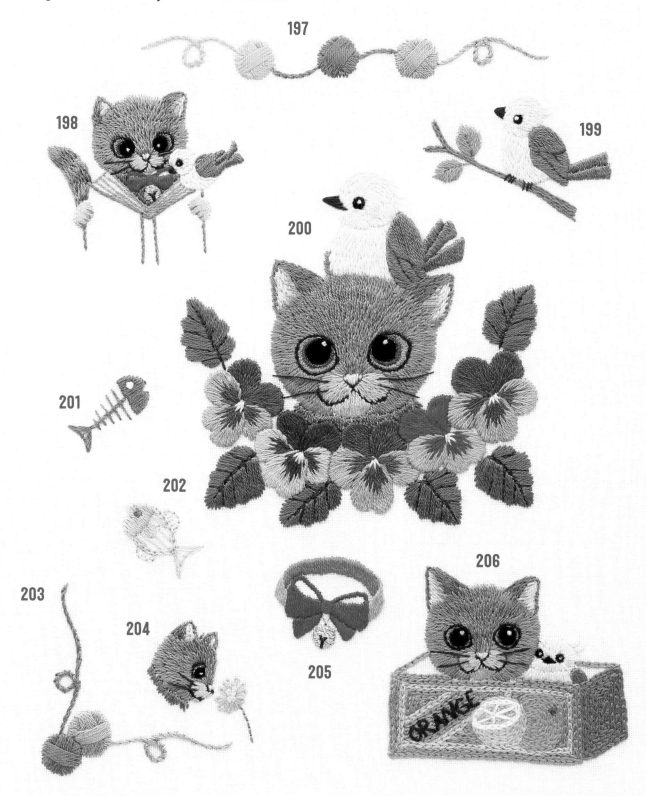

197

198

199

200

201

202

203

204

205

206

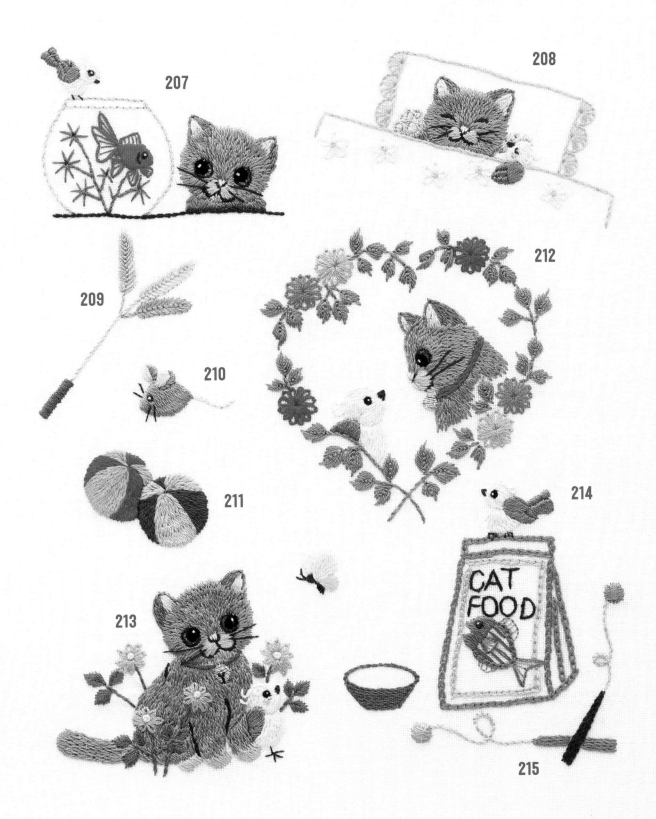

207

208

209

210

211

212

213

214

215

FOLK CATS

instructions: pages 100–103
design + embroidery: Nitka

216

217

218

219

220

221

222

223

224

225

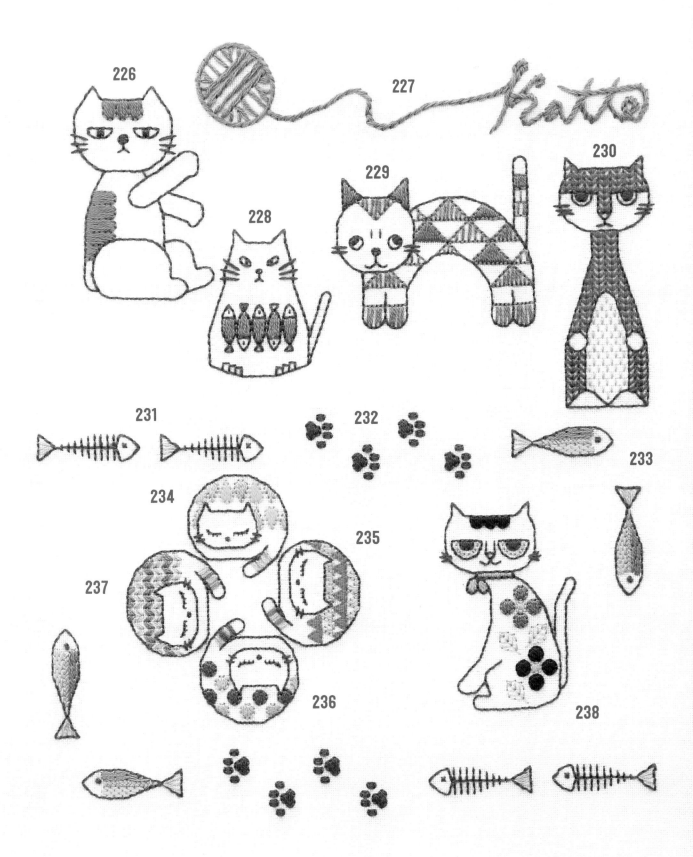

ALPHA-CATS

instructions: pages 104–107
design + embroidery: Shigeko Kawakami

239 A
240 B
241 C
242 D
243 E
244 F
245 G
246 H
247 I
248 J
249 K
250 L
251 M
252 N
253 O
254 P
255 Q
256 R
257 S
258 T
259 U
260 V
261 W
262 X
263 Y
264 Z

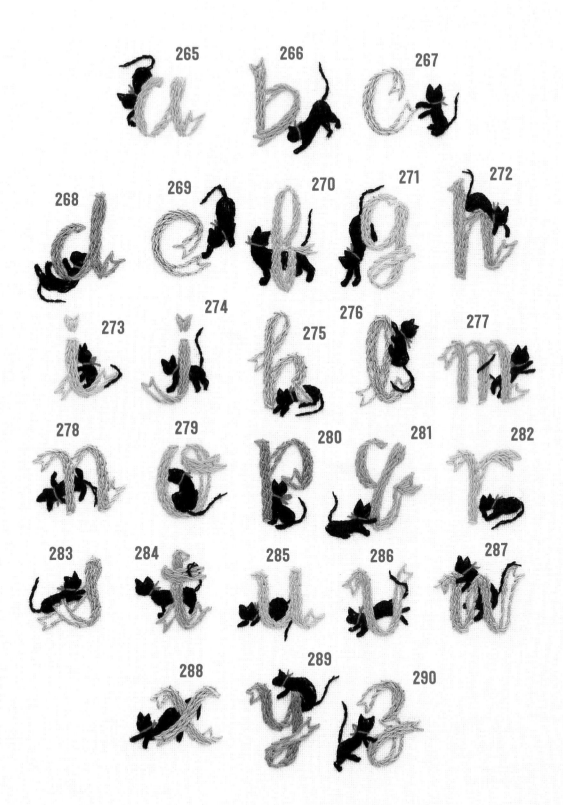

ALPHA-CATS

instructions: pages 108–111
design + embroidery: Yasuko Sebata

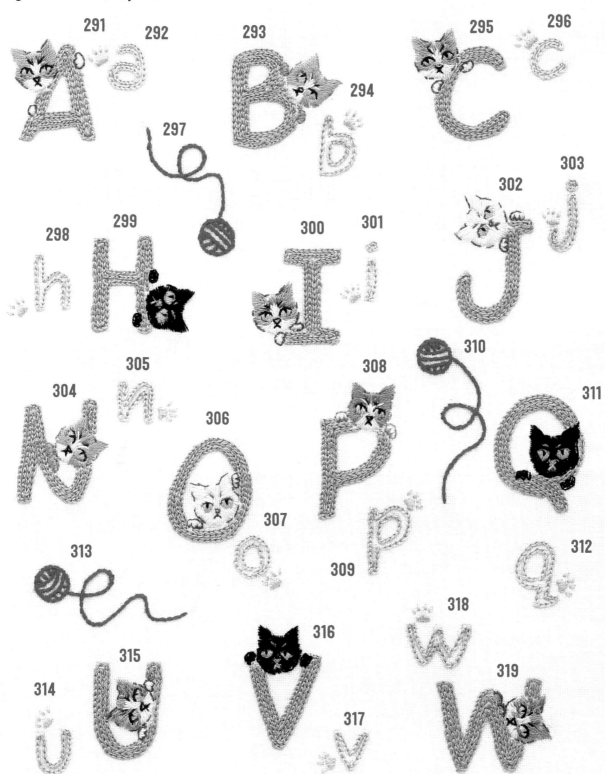

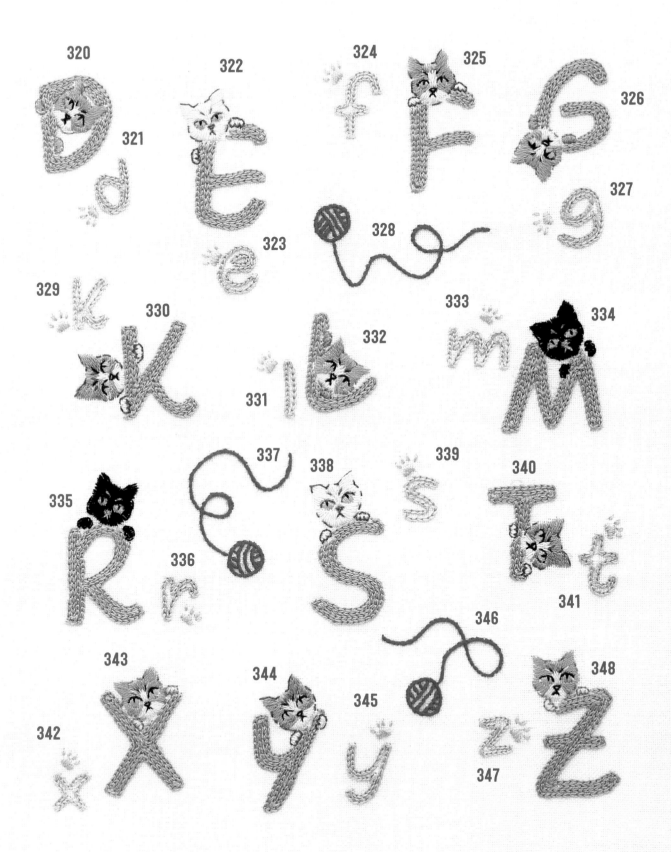

320
321
322
323
324
325
326
327
328
329
330
331
332
333
334
335
336
337
338
339
340
341
342
343
344
345
346
347
348

33

KITTY CORNERS

instructions: pages 112–115
design + embroidery: martinachakko (Hiroko Sonobe)

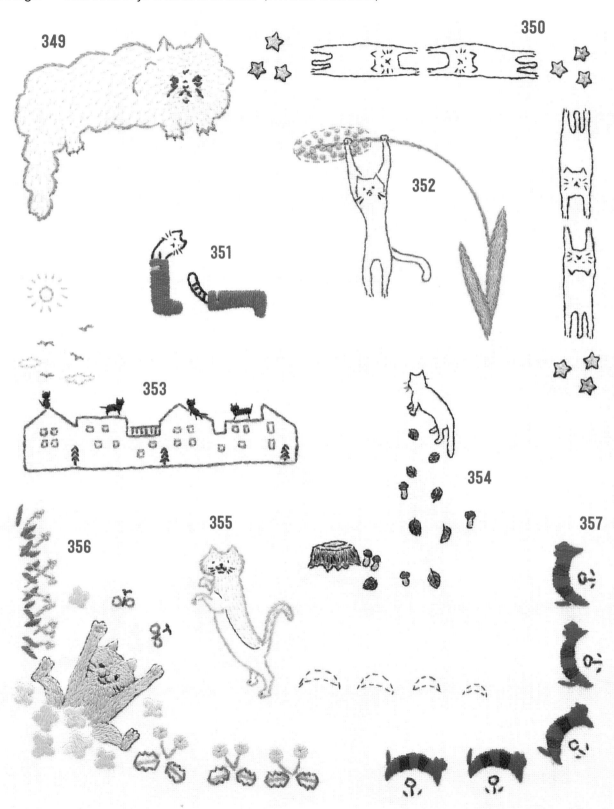

349

350

351

352

353

354

355

356

357

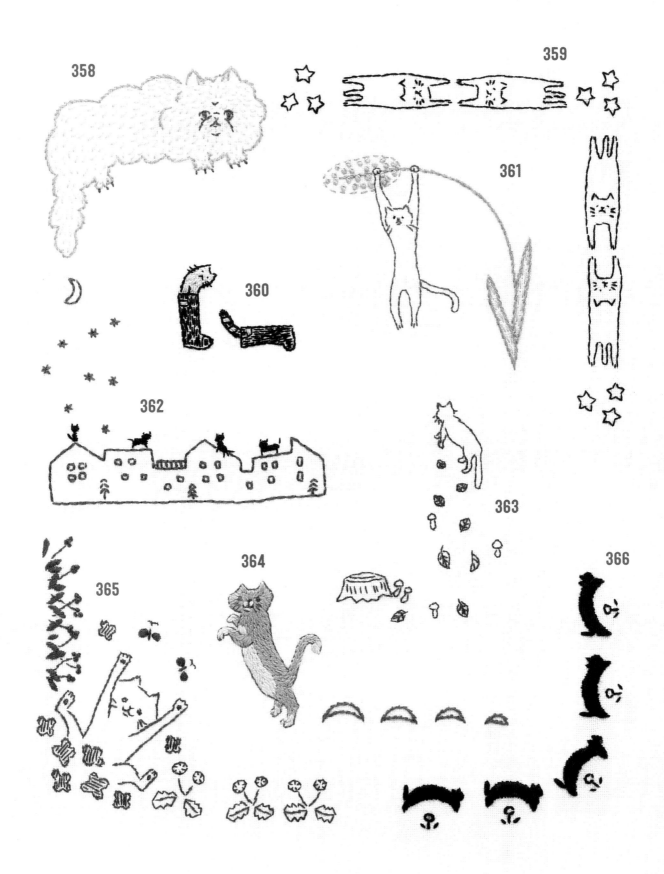

358

359

360

361

362

363

364

365

366

KITTY BORDERS

instructions: pages 116–119
design + embroidery: Shigeko Kawakami

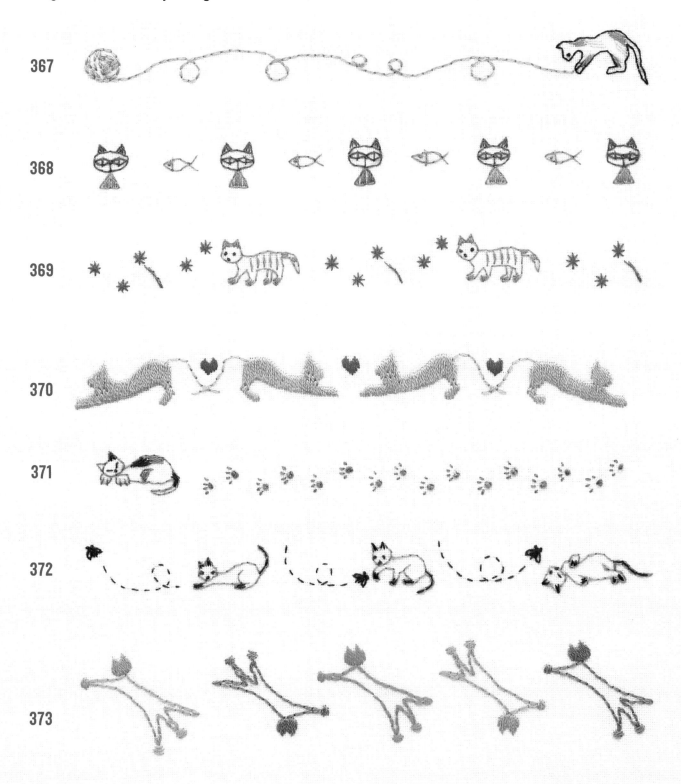

367

368

369

370

371

372

373

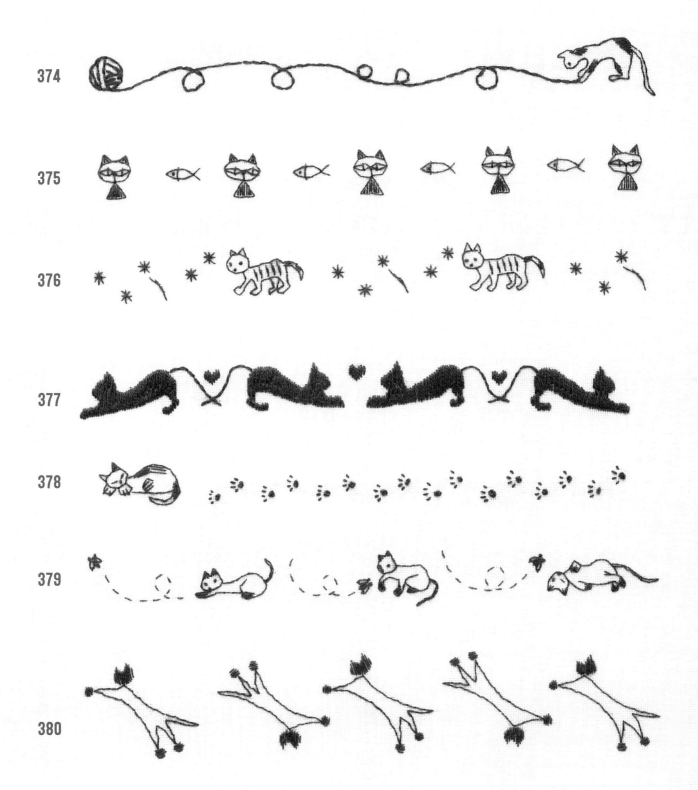

374

375

376

377

378

379

380

PROJECT INSPIRATION GALLERY

Embroider these adorable cat motifs on just about any fabric surface to add a whimsical touch. From clothing and table linens to pillows and pouches, the possiblities are endless.

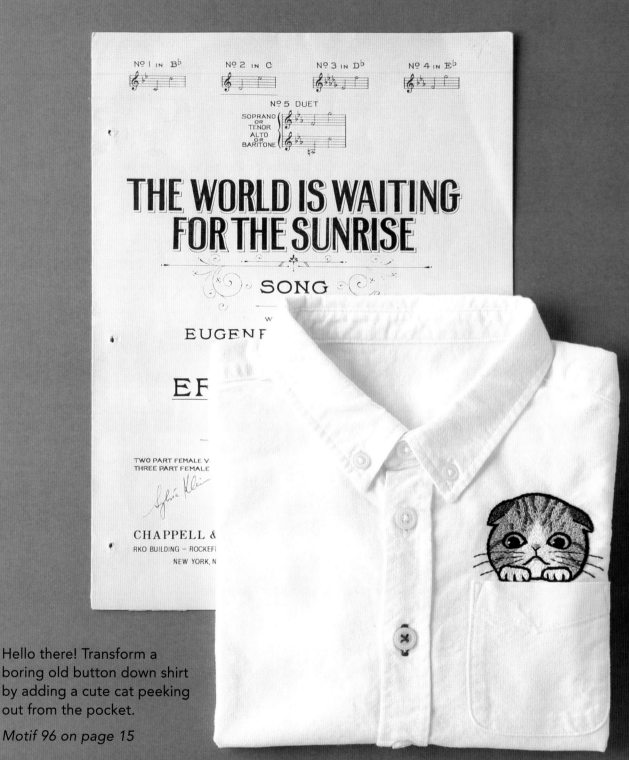

Hello there! Transform a boring old button down shirt by adding a cute cat peeking out from the pocket.

Motif 96 on page 15

These ankle socks embroidered with tiny kittens are perfect for little girls...or little girls at heart!

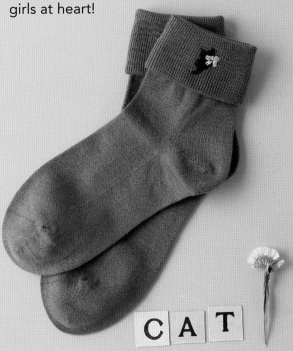

Motif 121 on page 17

These cozy cats will help keep your feet warm!

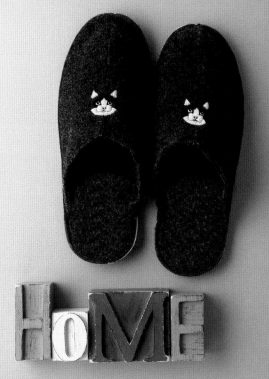

Motif 48 on page 10

A handkerchief personalized with a cat-themed initial makes a wonderful gift for fellow cat lovers.

Motif 274 on page 31

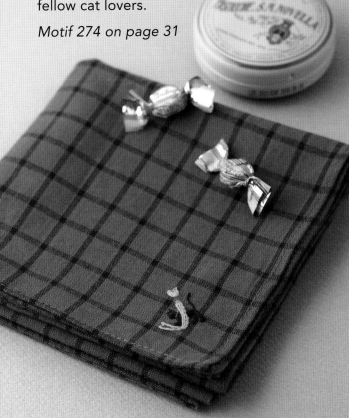

Stitch a quirky kitty onto your market tote and make grocery shopping fun.

Motif 80 on page 13

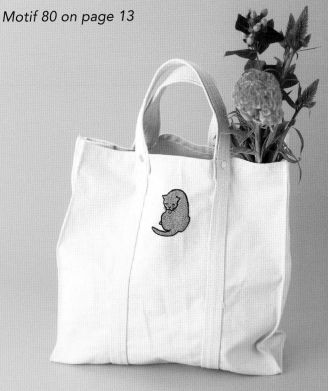

Stitch up a sampler featuring your favorite designs, then add a frame for one-of-a-kind home decor.

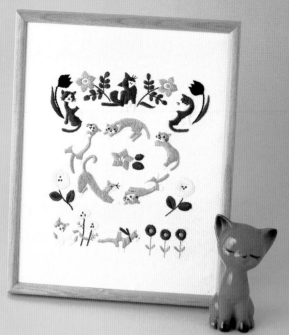

Motifs 122–137 on page 18

This little black cat makes the perfect companion for a journal or book cover.

Motif 172 on page 23

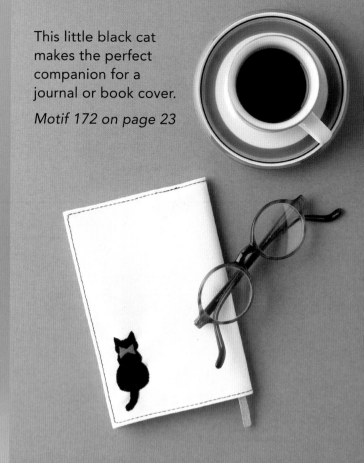

Add some fun cat-themed motifs to jazz up simple coasters.

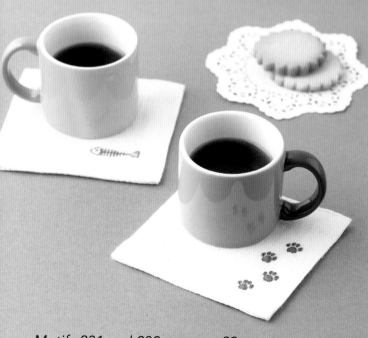

Motifs 231 and 232 on page 29

Personalize a pillow cover with one of the larger motifs.

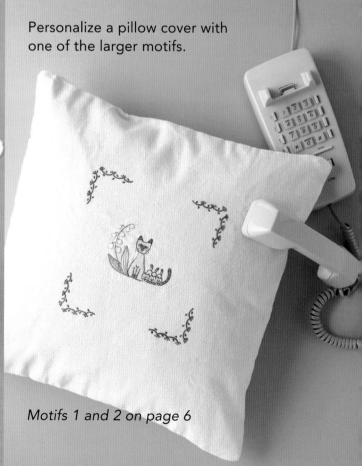

Motifs 1 and 2 on page 6

This folk-inspired cat motif makes a chic pencil case.

Motif 221 on page 28

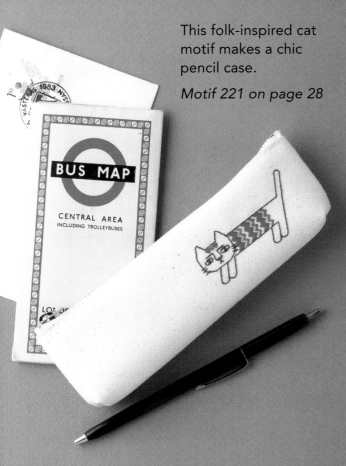

Stitch up a variety of the cat patterns, then add to hairbands to show off your love for felines.

Motifs 56 and 66 on page 11

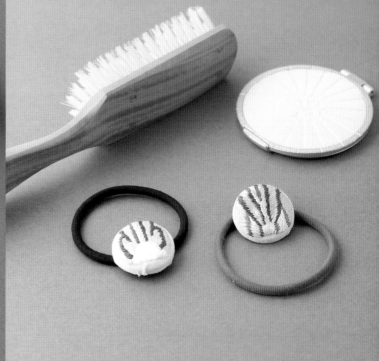

Embroider a cute kitten onto a bib or onesie for a sweet baby gift.

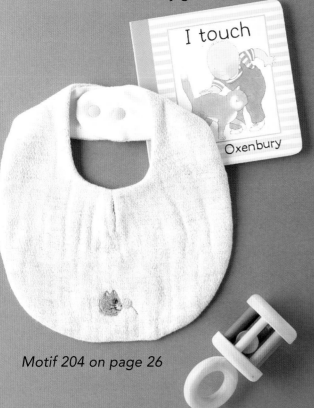

Motif 204 on page 26

Embroider one of the holiday-themed motifs onto felt, then add to a gift for a special touch.

Motif 117 on page 17

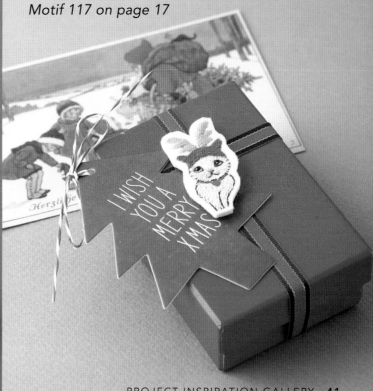

TOOLS & MATERIALS

EMBROIDERY FLOSS ------------------------------------

All of the designs in this book were created with No. 25 embroidery floss. This type of floss is composed of six strands that can be easily separated, allowing you to adjust the thickness. Olympus brand floss was used to stitch the designs in this book. A conversion chart for DMC brand is included on page 55.

No. 25 embroidery floss

Each skein of floss includes a label with a three- or four-digit color number. Metallic embroidery floss colors include an S before the color number. These numbers are used to represent the required floss color in the stitch diagram for each design.

Metallic embroidery floss

NEEDLES ------------------------------------

Use embroidery needles, which feature large eyes designed to accommodate embroidery floss. French embroidery needles are popular for their sharp tips that travel through a variety of fabrics with ease. Embroidery needles are available in several sizes, but sizes 3–7 should work for the designs in this book. Use the proper size needle based on the number of threads.

Remember, the higher the needle size, the smaller the needle!

Size 3
Size 5
Size 7

French embroidery needles

Needle Size	Number of Strands
No. 3	6
No. 5	3–4
No. 7	1–2

SCISSORS

Use small thread snips to cut embroidery floss and fabric shears to cut embroidery fabric. Remember, sharp scissors make the job easier!

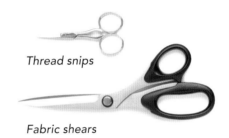

Thread snips

Fabric shears

FABRICS & HOOPS

You can embroider just about any type of fabric, including cotton, linen, felt, and wool. For best results, look for a plain-woven fabric designed especially for embroidery.

Use an embroidery hoop to hold your fabric taut while stitching and prevent it from puckering. A 4–6 in (10–15 cm) hoop will work for most of the designs in this book.

GETTING STARTED

HOW TO TRANSFER THE DESIGNS -

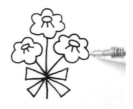

1. Position dress-maker's carbon paper on your embroidery fabric with the chalk side down.

2. Copy the motif onto tracing paper. Align the tracing paper on top of the dressmaker's carbon paper. Position a sheet of cellophane on top.

3. Trace the motif using a stylus or ballpoint pen.

The cellophane isn't absolutely necessary, but it protects the tracing paper and makes the tracing process smoother.

4. The pressure of the pen will transfer the chalk onto the embroidery fabric in the outline of the motif.

HOW TO PREPARE EMBROIDERY FLOSS -

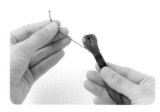

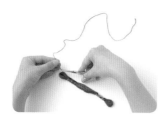

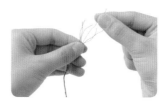

1. Hold the skein of embroidery floss with the label positioned between your fingers. Slowly pull one end.

2. Cut a 16–20 in (40–50 cm) long piece.

3. Separate the individual strands.

4. Realign the number of strands needed to stitch the design. Always separate the strands, even when using all six strands as this practice prevents the thread from knotting.

HOW TO THREAD THE NEEDLE -

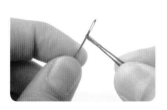 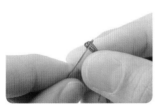 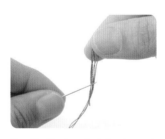

1. Make a fold about 1 in (2.5 cm) from the end of the floss. Use your needle to apply pressure and create a crease.

2. Insert the fold through the eye of the needle.

3. Pull the folded end through the eye of the needle.

4. Position the needle about 4 in (10 cm) from the crease.

HOW TO MAKE KNOTS -

TO START STITCHING

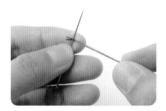 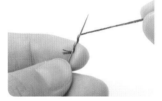 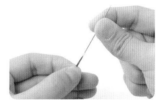

1. Align the needle and the end of the floss.

2. Wrap the floss around the needle once or twice.

3. Hold the wraps between your fingers and pull the needle out. Move the wraps to the end of the floss to create a knot.

4. The knot is complete.

TO FINISH STITCHING

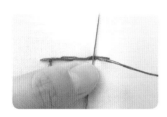 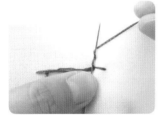 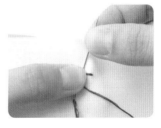 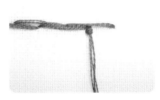

1. Align the needle on top of the stitches on the wrong side of the embroidery fabric.

2. Wrap the floss around the needle once or twice.

3. Use your finger to hold the wraps against the fabric and pull the needle out.

4. The knot is complete.

RIGHT SIDE VS. WRONG SIDE -------------------------------

The wrong side of your embroidery is just as important as the right side because it can influence the finished appearance of your work. Always start and finish your threads as shown on the previous page in order to produce neat, professional-looking finished designs.

When starting a new area of stitching, start a new thread or pass the needle under the back of other stitches to move to the new area, even if you're using the same color floss. This way, you'll avoid having long threads visible on the right side of your work. This is especially important when you're embroidering on light fabric.

The following photos show finished motifs as they appear on both the right and wrong sides.

Right Side　　　　　　　　　*Wrong Side*

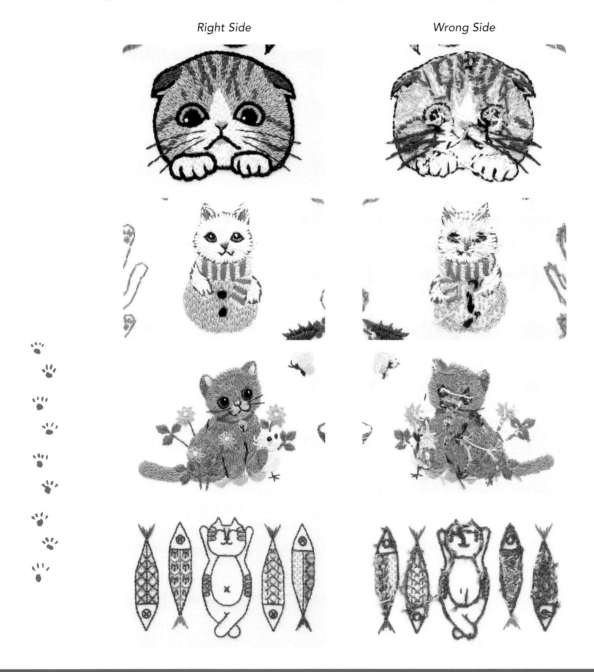

EMBROIDERY FLOSS --

Since No. 25 embroidery floss is composed of six strands, you can separate the strands to adjust the thickness of your stitching. The following guide shows the different results that can be achieved by stitching with different numbers of strands.

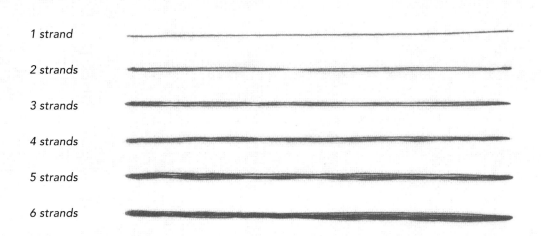

1 strand

2 strands

3 strands

4 strands

5 strands

6 strands

Altering the number of strands will influence the finished look of your stitches. The following examples show the different results than can be achieved by altering the number of strands of embroidery floss.

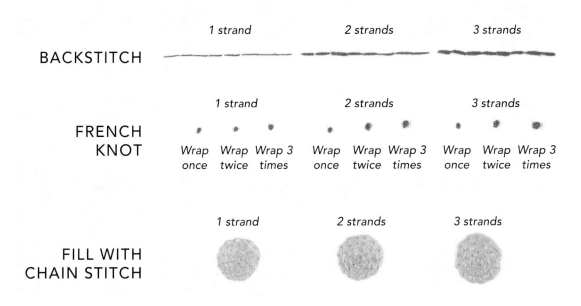

	1 strand			2 strands			3 strands		
BACKSTITCH									

	1 strand			2 strands			3 strands		
FRENCH KNOT	Wrap once	Wrap twice	Wrap 3 times	Wrap once	Wrap twice	Wrap 3 times	Wrap once	Wrap twice	Wrap 3 times

	1 strand	2 strands	3 strands
FILL WITH CHAIN STITCH			

EMBROIDERY STITCH GUIDE

All of the designs in this book were made with 15 basic embroidery stitches. The following guide illustrates how to make each stitch.

▶ STRAIGHT STITCH

▶ RUNNING STITCH

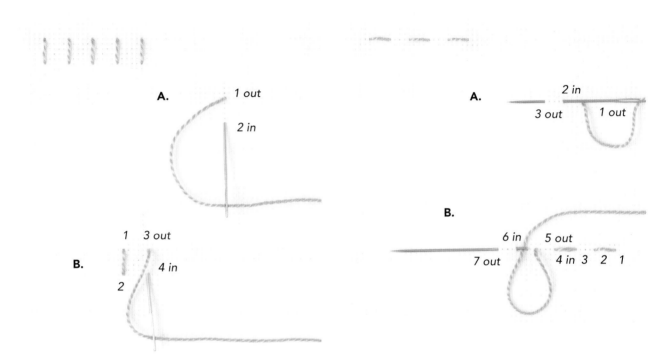

A. Draw the needle out at 1 and insert at 2. One straight stitch is complete.

B. To make the next stitch, draw the needle out at 3 and insert at 4.

A. Draw the needle out at 1. Insert at 2 and draw it out again at 3 in one movement.

B. Continue making a couple stitches at a time. Take care to keep the spacing consistent between stitches.

▶ BACKSTITCH

A. Draw the needle out at 1. Insert at 2, which is one stitch length behind 1. Draw the needle out again at 3, which is one stitch length ahead of 1.

B. To make the next stitch, insert the needle at 4, which is actually the same hole as 1. Draw the needle out again at 5, which is one stitch length ahead of 3.

▶ OUTLINE STITCH

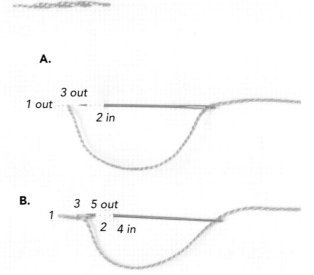

This stitch is worked from left to right.

A. Draw the needle out at 1. Insert the needle one stitch length away at 2, then draw the needle out again at 3, which is halfway between 1 and 2.

B. To make the next stitch, insert the needle one stitch length away at 4. Draw the needle out again at 5, which is halfway between 3 and 4.

▶ CHAIN STITCH

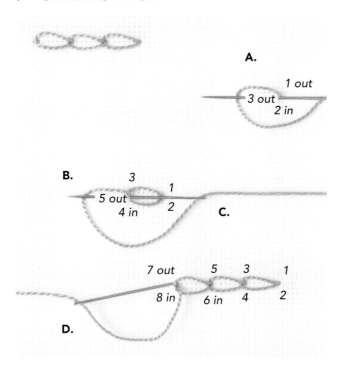

A. Draw the needle out at 1. Wrap the floss around the needle tip. Insert the needle at 2 (this is actually the same hole as 1), then draw the needle out again at 3.

B. Pull the needle and floss through the fabric until a small loop remains. The first chain is now complete. Insert the needle back through the same hole at 4.

C. Use the same process to draw the needle tip out at 5 and complete the next chain.

D. To finish a row of chain stitch, insert the needle back through the fabric, making a tiny straight stitch to secure the final chain, as shown by 8.

▶ FRENCH KNOT

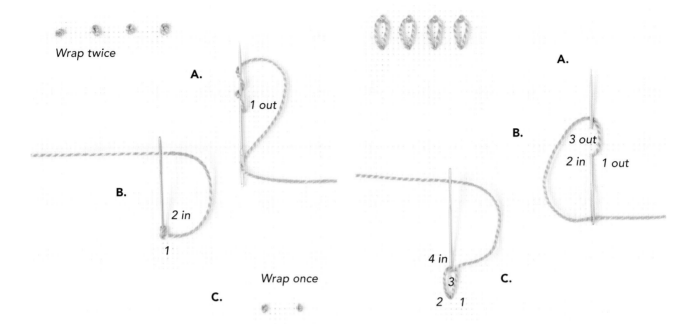

Wrap twice

A.

1 out

B.

2 in

1

Wrap once

C.

A. Draw the needle out at 1. Wrap the thread around the needle tip twice.

B. Insert the needle back through the fabric at 2, just next to 1. Hold the wraps against the fabric as you pull the needle and thread through the fabric to complete the knot.

C. For smaller French knots, wrap the thread around the needle only once.

▶ LAZY DAISY STITCH

A.

B.

3 out

2 in *1 out*

4 in

3

C.

2 1

A. Draw the needle out at 1. Wrap the floss around the needle tip. Insert the needle at 2 (this is actually the same hole as 1), then draw the needle out again at 3.

B. This is the same process used to make a chain stitch as shown on page 49.

C. Pull the needle and floss through the fabric until a small loop remains. Insert the needle at 4, making a tiny straight stitch to secure the loop.

▶ SATIN STITCH

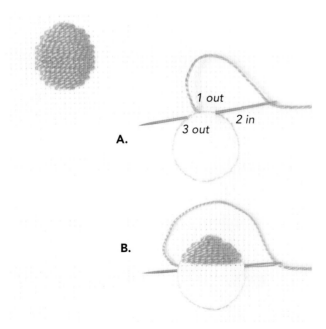

1 out

2 in

3 out

A.

B.

A. Draw the needle out at 1, insert it at 2, then draw the needle out again at 3.

B. Continue stitching from outline to outline to fill the area.

▶ LONG AND SHORT STITCH

▶ CROSS STITCH

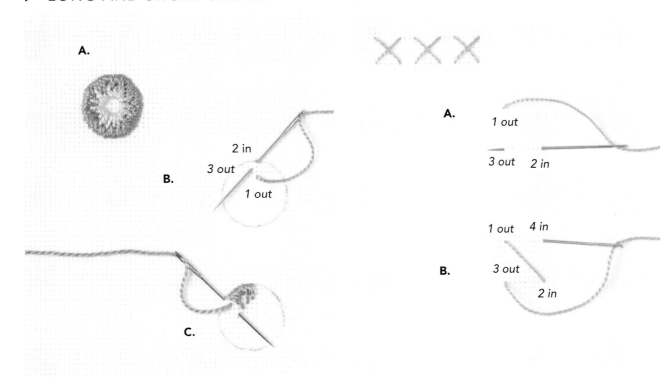

A. Draw the needle out at 1. Insert the needle at 2, then draw the needle out again at 3.

B. The distance from 2 to 3 should be shorter than the distance from 1 to 2.

C. Continue making both long and short stitches to fill the area.

It doesn't matter whether you cross the stitches from top to bottom or bottom to top, just be consistent throughout your work.

A. Draw the needle out at 1. Make a diagonal stitch and insert the needle at 2. Draw the needle out again at 3, which is parallel to 2.

B. Make another diagonal stitch to complete the cross and insert the needle at 4, which is parallel to 1.

▶ FISHBONE STITCH

▶ BULLION KNOT

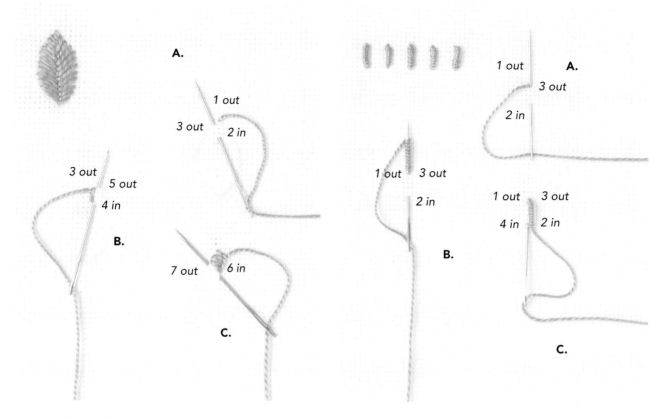

A. Draw the needle out at 1, which is at the tip of the design. Insert the needle at 2 in the center of the design. Draw the needle out at 3 along the left edge of the design.

B. Next, insert the needle at 4, which is adjacent to 2. Draw the needle out at 5 along the right edge of the design.

C. Insert the needle at 6, just beneath 4 and 5. Draw the needle out at 7. Continue working diagonal stitches from the center of the design.

A. Draw the needle out at 1 (this will be the top of the knot). Insert the needle at 2, then draw the needle out again at 3, which is actually the same hole as 1.

B. Wrap the floss around the tip of the needle as many times as directed. Hold the wraps against the fabric as you pull the needle out.

C. Insert the needle at 4, which is actually the same hole as 2, to secure the knot against the fabric.

▶ FLY STITCH

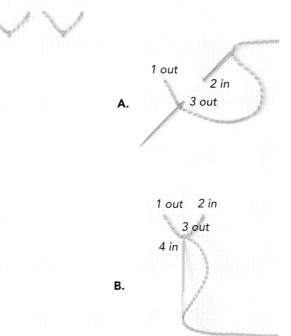

▶ BLANKET STITCH

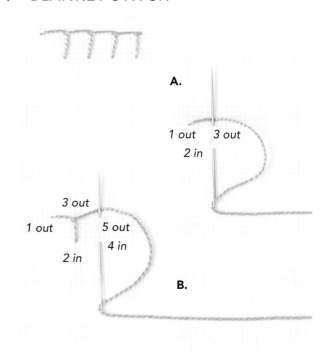

A. Draw the needle out at 1. Arrange the floss at a downward diagonal angle, then insert the needle at 2, which is parallel to 1. Draw the needle out at 3.

B. Pull the floss through the fabric to form a V-shaped stitch. Insert the needle at 4, directly beneath 3, to make a tiny straight stitch and secure the V in place.

A. Draw the needle out at 1. Arrange the floss so it extends to the right. Insert the needle at 2, then draw it out at 3, which is parallel to 1. Take care to keep the floss under the needle.

B. To make the next stitch, arrange the floss so it extends to the right, then insert the needle at 4, which is parallel to 2. Draw the needle out at 5, which is parallel to 1 and 3, taking care to keep the floss under the needle.

▶ COUCHING STITCH

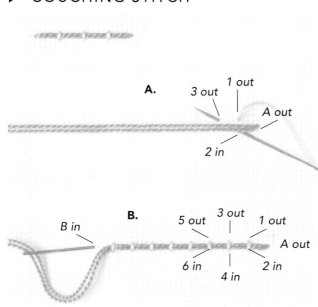

This example uses two different colors of floss to illustrate how to work the couching stitch. Refer to individual motif instructions for floss colors.

A. Draw the main floss color out at A, then arrange along the motif line. Draw the secondary floss color out at 1. Insert at 2, directly below 1, making a tiny straight stitch to secure the main floss in place. Draw the needle out at 3.

B. Continue making tiny, equally spaced straight stitches to secure the main floss in place along the motif line. To finish stitching, insert the main floss color back through the fabric at B.

HOW TO USE THIS BOOK

Each motif in this book comes with a stitch guide, which includes all the information you'll need to stitch up the design, as well as a full-size template that can be traced easily. At the top of each page, you'll also find some general information that applies to all the motifs included on that page. The following guide explains how to read the embroidery diagrams.

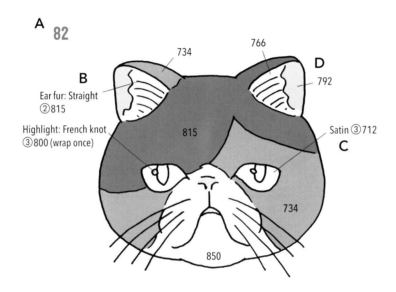

A. Motif Number: Use the motif number to locate your design. These numbers are also included on the photos of the stitched motifs at the beginning of the book.

B. Stitch Name: These labels indicate which stitch to use for each element of the design. Note: The word "stitch" is omitted from these labels in order to save space. Refer to the Stitch Guide on pages 48–53 for instructions on making each of the 15 basic stitches used in this book.

C. Number of Strands: The circled numbers (for example: ②) indicate how many strands of embroidery floss to use when making a stitch.

D. Color Number: These numbers indicate the required floss color. Olympus brand floss was used to stitch the designs in this book. A conversion chart for DMC brand is included on page 55.

THREAD CONVERSION CHART

OLYMPUS	DMC	OLYMPUS	DMC	OLYMPUS	DMC	OLYMPUS	DMC	OLYMPUS	DMC
101	819	274	3347	453	451	655	902	900	310
104	3326	275	3346	483	415	704	921	1013	899
123	605	276	3346	484	762	711	3854	1027	347
129	601	277	895	485	318	712	921	1028	321
133	554	284	833	486	414	714	300	1029	814
137	221	285	830	487	413	721	3856	1031	818
140	754	287	472	488	413	723	977	1032	3354
141	353	291	727	501	726	731	712	1034	3350
142	352	293	370	502	725	733	822	1035	347
144	350	301	747	503	725	734	734	1044	3716
145	349	302	828	512	741	735	437	1051	947
154	893	303	932	514	976	736	435	1052	608
155	892	304	518	516	782	737	433	1053	900
156	891	305	3760	525	741	738	801	1081	353
163	224	306	824	531	437	739	938	1205	3712
166	223	308	824	533	741	740	543	1600	225
167	221	314	519	534	740	741	842	1601	316
170	353	316	924	535	971	743	841	1603	221
184	351	318	939	543	307	744	3863	1704	760
186	350	324	310	546	444	745	975	1906	3831
188	304	331	775	551	727	752	402	2011	733
190	817	334	311	553	743	755	720	2014	937
198	902	341	927	555	741	758	920	2016	935
202	503	343	3847	561	831	765	224	2020	3819
203	502	344	924	562	3822	766	224	2021	907
204	3848	353	3761	563	3045	778	3857	2041	598
210	471	354	826	564	435	784	922	2042	597
212	471	366	797	565	830	785	976	2052	3363
214	731	367	796	575	400	791	225	2070	3348
218	469	370	827	581	973	792	225	2072	3850
220	747	371	996	582	742	796	221	3041	3024
221	3766	372	3844	583	972	800	B5200	3042	415
222	992	385	3843	600	211	801	BLANC	3705	827
223	3810	386	3810	601	153	810	762	5205	727
228	772	390	3811	602	554	811	3024	7010	712
232	700	411	3024	603	3825	812	648	7020	3866
236	523	412	648	605	550	813	3022	7025	3857
243	369	413	647	623	210	814	3023	S101	E316/5288
244	368	414	646	630	3742	815	611	S105	E168/5283
245	367	415	645	631	3743	825	801	S106	E3821/5282
246	501	416	535	632	3042	841	822		
247	319	430	3072	641	3840	842	3033		
261	955	440	413	642	794	843	612		
262	954	441	3799	644	336	844	611		
265	909	451	453	651	3042	845	611		
273	3012	452	452	653	3042	850	3865		

CURIOUS CATS

- ○ = Number of strands (use 1 strand unless otherwise noted) ■ # = Color number
- Fill with straight stitch unless otherwise noted.

1

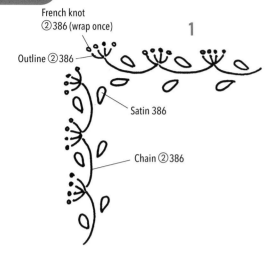

French knot
②386 (wrap once)

Outline ②386

Satin 386

Chain ②386

2

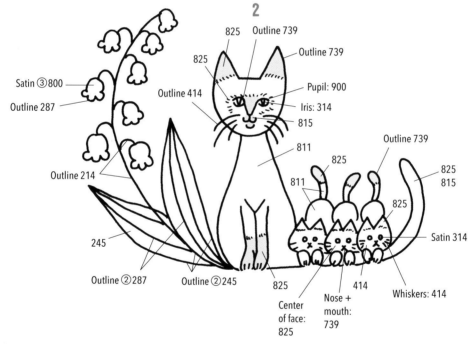

Satin ③800

Outline 287

Outline 214

245

Outline ②287

Outline ②245

825

Outline 414

825

825

Outline 739

Outline 739

Pupil: 900

Iris: 314

815

811

811

825

Outline 739

825
815

825

Satin 314

Center
of face:
825

Nose +
mouth:
739

414

Whiskers: 414

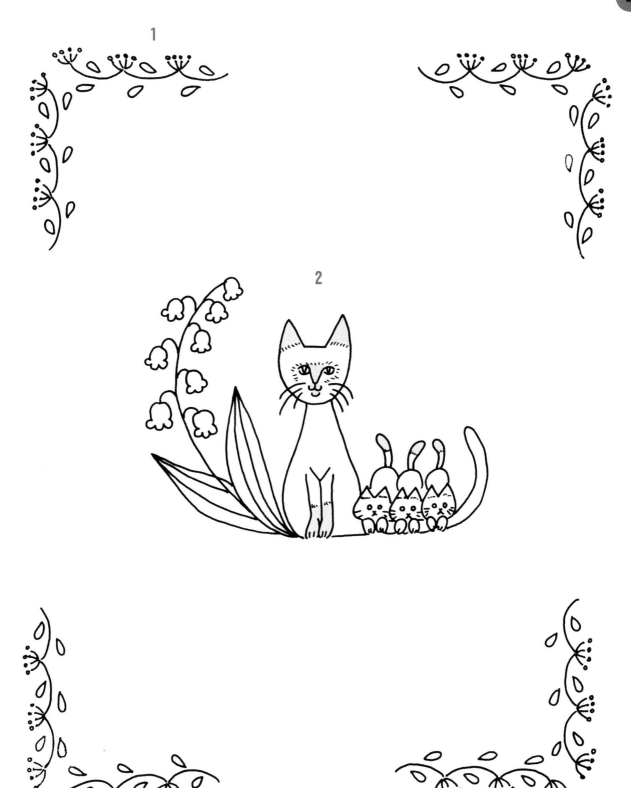

1

2

■ ○ = Number of strands (use 1 strand unless otherwise noted) ■ # = Color number ■ Straight stitch unless otherwise noted. ■ Outline stitch 900 for the nose, mouth, and head and body outlines unless otherwise noted.

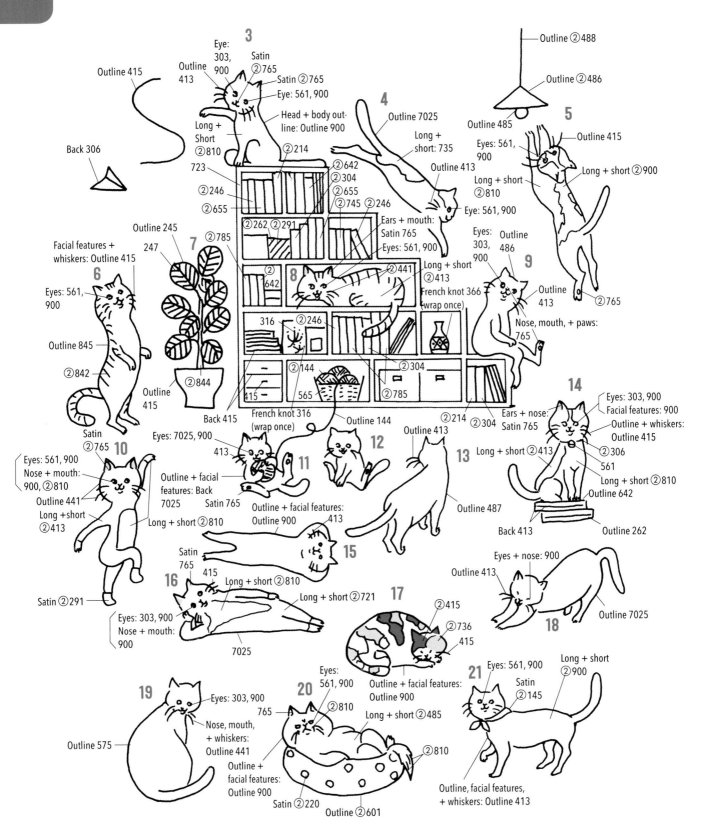

3

Eye: 303, 900
Outline 413
Satin ②765
Satin ②765
Eye: 561, 900
Head + body out-line: Outline 900
Outline 415
Back 306
Long + Short ②810
723
②214
②246
②655
②642
②304
②655
②745 ②246
②785
②262 ②291

4
Outline 7025
Long + short: 735
Outline 413
Eye: 561, 900
Ears + mouth: Satin 765
Eyes: 561, 900

5
Outline ②488
Outline ②486
Outline 485
Outline 415
Eyes: 561, 900
Long + short ②900
Long + short ②810
②765

Outline 245
247
7
Facial features + whiskers: Outline 415
6
Eyes: 561, 900
Outline 845
②842
Outline 415
②844

8
②642
316 ②246
415
Back 415
French knot 316 (wrap once)
Outline 144
②144
565
②785
②441
Long + short ②413
French knot 366 (wrap once)
②304
②214 ②304

9
Eyes: 303, 900
Outline 486
Outline 413
Nose, mouth, + paws: 765
②765

Ears + nose: Satin 765

14
Eyes: 303, 900
Facial features: 900
Outline + whiskers: Outline 415
②306
561
Long + short ②810
Outline 642

13
Outline 413
Long + short ②413
Back 413
Outline 487
Outline 262

Eyes: 7025, 900
413
11
Outline + facial features: Back 7025
Satin 765
Outline + facial features: Outline 900
12
413

10
Eyes: 561, 900
Nose + mouth: 900, ②810
Outline 441
Long +short ②413
Satin ②765
Long + short ②810
Satin ②291

Satin 765
415
16
Long + short ②810
413
15
Long + short ②721
Eyes: 303, 900
Nose + mouth: 900
7025

17
②415
②736
415
Outline + facial features: Outline 900

Eyes + nose: 900
Outline 413
Outline 7025
18

19
Eyes: 303, 900
Nose, mouth, + whiskers: Outline 441
Outline 575

20
Eyes: 561, 900
765
②810
Long + short ②485
②810
Outline + facial features: Outline 900
Satin ②220
Outline ②601

21
Eyes: 561, 900
Long + short ②900
Satin ②145
Outline, facial features, + whiskers: Outline 413

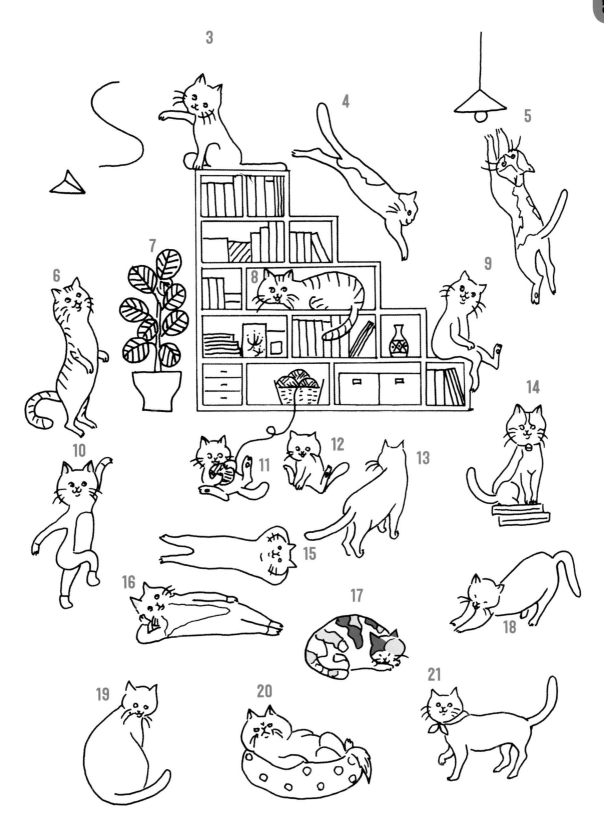

FELINE FACES

photos: pages 8–9

■ ○ = Number of strands (use 3 strands unless otherwise noted) ■ # = Color number ■ Satin stitch unless otherwise noted.

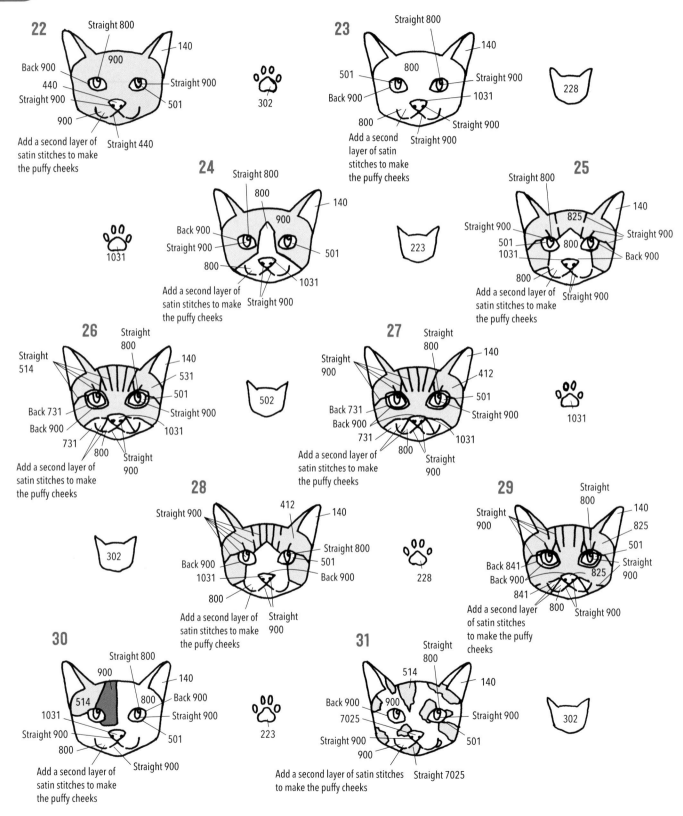

22
Straight 800
900
140
Back 900
440
Straight 900
900
Straight 900
Straight 440
501
Add a second layer of satin stitches to make the puffy cheeks
302

23
Straight 800
140
800
501
Straight 900
Back 900
1031
800
Straight 900
Add a second layer of satin stitches to make the puffy cheeks
228

24
Straight 800
800
900
140
Back 900
Straight 900
501
800
1031
Straight 900
Add a second layer of satin stitches to make the puffy cheeks
1031

25
Straight 800
825
140
Straight 900
Straight 900
501
800
1031
Back 900
800
Straight 900
Add a second layer of satin stitches to make the puffy cheeks
223

26
Straight 800
Straight 514
140
531
501
Back 731
Straight 900
Back 900
1031
731
800
Straight 900
Add a second layer of satin stitches to make the puffy cheeks
502

27
Straight 800
Straight 900
140
412
501
Back 731
Straight 900
Back 900
1031
731
800
Straight 900
Add a second layer of satin stitches to make the puffy cheeks
1031

28
Straight 900
412
140
Straight 800
501
Back 900
Back 900
1031
800
Add a second layer of satin stitches to make the puffy cheeks
Straight 900
228

29
Straight 800
Straight 900
140
825
501
Back 841
Straight 900
Back 900
825
841
800
Straight 900
Add a second layer of satin stitches to make the puffy cheeks
302

30
Straight 800
900
140
800
Back 900
514
Straight 900
1031
900
Straight 900
800
501
Straight 900
Add a second layer of satin stitches to make the puffy cheeks
223

31
Straight 800
514
140
Back 900
900
7025
Straight 900
Straight 900
900
501
Straight 7025
Add a second layer of satin stitches to make the puffy cheeks
302

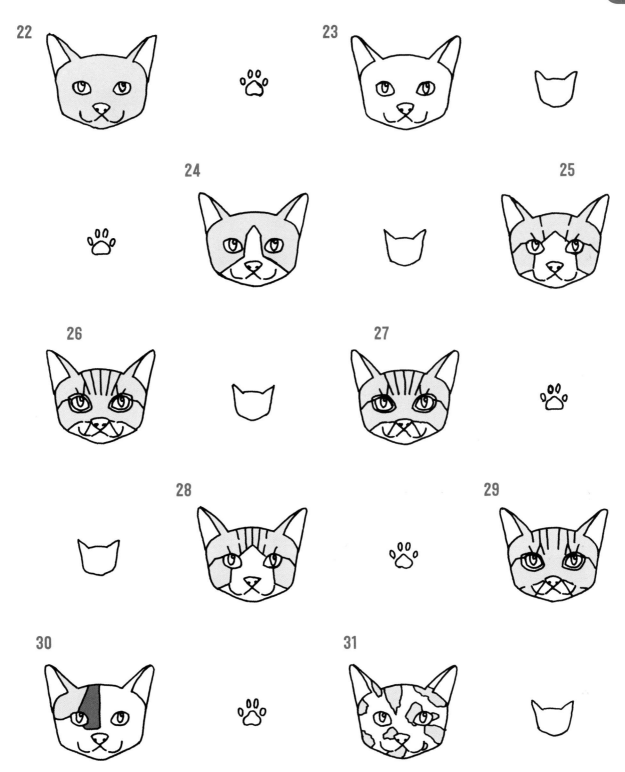

22 23 24 25 26 27 28 29 30 31

■ ○ = Number of strands (use 3 strands unless otherwise noted) ■ # = Color number
■ Satin stitch unless otherwise noted.

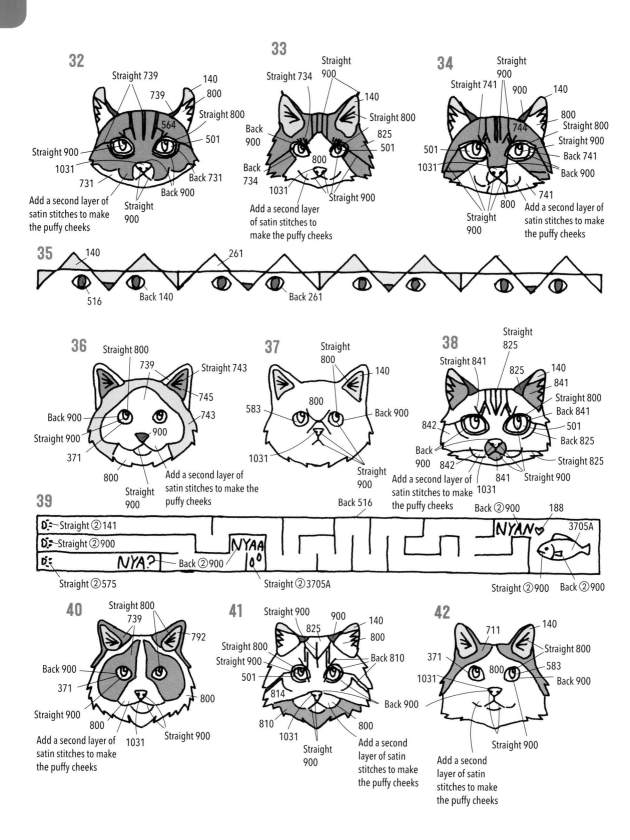

32
Straight 739
739
140
800
Straight 800
564
501
Straight 900
1031
731
Back 731
Back 900
Add a second layer of satin stitches to make the puffy cheeks
Straight 900

33
Straight 734
Straight 900
140
Straight 800
Back 900
825
501
Back 734
800
1031
Straight 900
Add a second layer of satin stitches to make the puffy cheeks

34
Straight 741
Straight 900
900
140
800
744
Straight 800
Straight 900
501
Back 741
1031
Back 900
741
800
Straight 900
Add a second layer of satin stitches to make the puffy cheeks

35
140
261
516
Back 140
Back 261

36
Straight 800
739
Straight 743
745
743
Back 900
900
Straight 900
371
800
Straight 900

37
Straight 800
140
800
583
Back 900
1031
Straight 900

38
Straight 825
Straight 841
825
140
841
825
Straight 800
Back 841
842
501
Back 825
Back 900
842
Straight 825
841
Straight 900
Add a second layer of satin stitches to make 1031 the puffy cheeks

Add a second layer of satin stitches to make the puffy cheeks
Back 516

39
◑∶ Straight ②141
◑∶ Straight ②900
◑∶ NYA? Back ②900
Straight ②575
NYAA 0⁰
Straight ②3705A
NYAN♥
188
3705A
Back ②900
Straight ②900 Back ②900

40
Straight 800
739
792
Back 900
371
800
Straight 900
800
1031
Straight 900
Add a second layer of satin stitches to make the puffy cheeks

41
Straight 900
825
900
140
800
Straight 800
Straight 900
Back 810
501
814
810
1031
Back 900
800
Straight 900
Add a second layer of satin stitches to make the puffy cheeks

42
711
140
371
Straight 800
800
583
1031
Back 900
Straight 900
Add a second layer of satin stitches to make the puffy cheeks

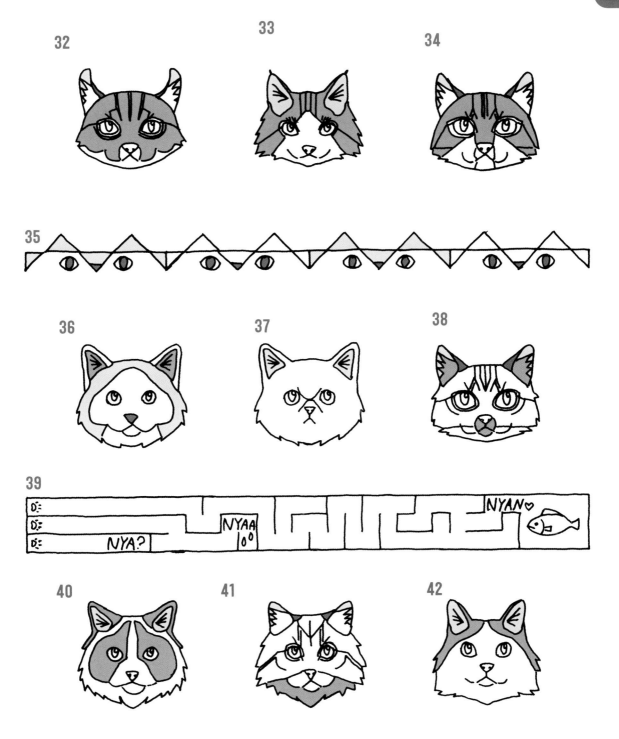

HEADS & TAILS

photos: pages 10–11

■ ○ = Number of strands (use 3 strands unless otherwise noted) ■ # = Color number ■ Satin stitch unless otherwise noted, except for 43–45 and 53–55. Use long and short stitch for these motifs.

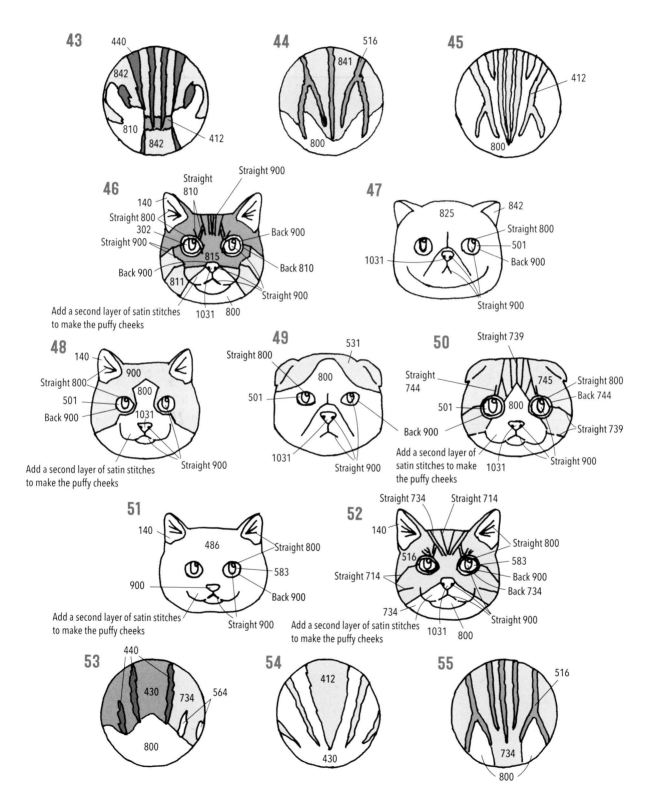

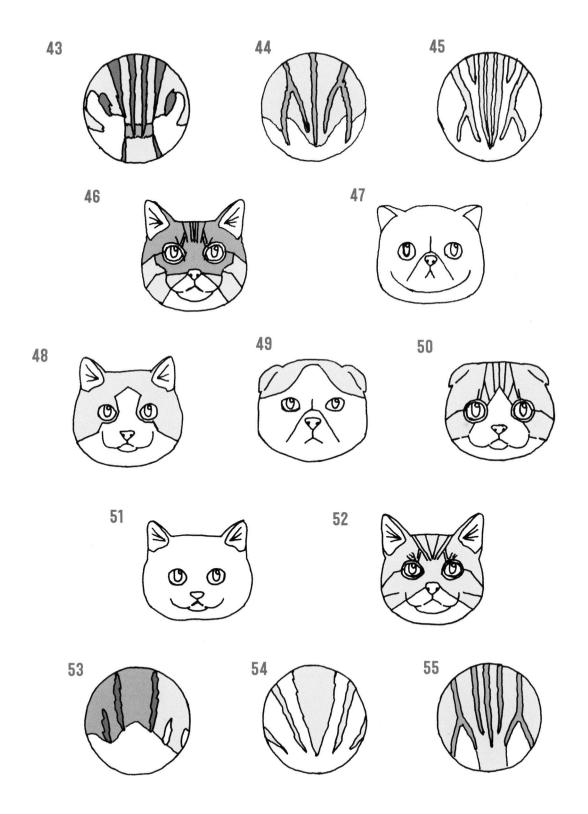

43

44

45

46

47

48

49

50

51

52

53

54

55

■ ◯ = Number of strands (use 3 strands unless otherwise noted) ■ # = Color number ■ Satin stitch unless otherwise noted, except for 56–57, 61–62 and 66–67. Use long and short stitch for these motifs.

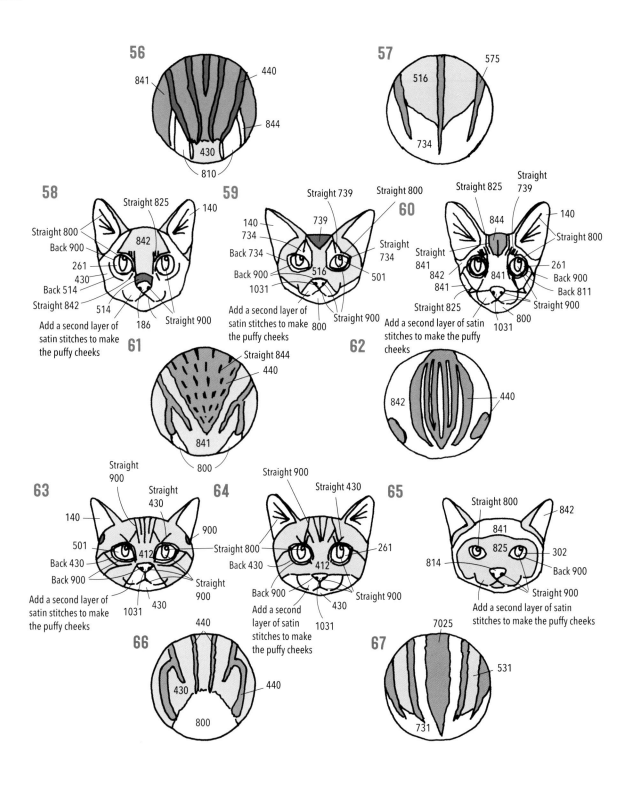

56
841
440
844
430
810

57
516
575
734

58
Straight 825
Straight 800
Back 900
261
430
Back 514
Straight 842
842
140
514
186
Straight 900
Add a second layer of satin stitches to make the puffy cheeks

59
Straight 739
Straight 800
140
734
739
Back 734
Back 900
1031
516
Straight 734
501
800
Straight 900
Add a second layer of satin stitches to make the puffy cheeks

60
Straight 825
Straight 739
844
140
Straight 841
842
841
841
Straight 825
261
Back 900
Back 811
Straight 900
800
1031
Add a second layer of satin stitches to make the puffy cheeks

61
Straight 844
440
841
800

62
842
440

63
Straight 900
Straight 430
140
900
501
412
Back 430
Back 900
Straight 900
1031
430
Add a second layer of satin stitches to make the puffy cheeks

64
Straight 900
Straight 430
Straight 800
261
Back 430
412
Back 900
Straight 900
430
1031
Add a second layer of satin stitches to make the puffy cheeks

65
Straight 800
842
841
825
302
814
Back 900
Straight 900
Add a second layer of satin stitches to make the puffy cheeks

66
440
430
440
800

67
7025
531
731

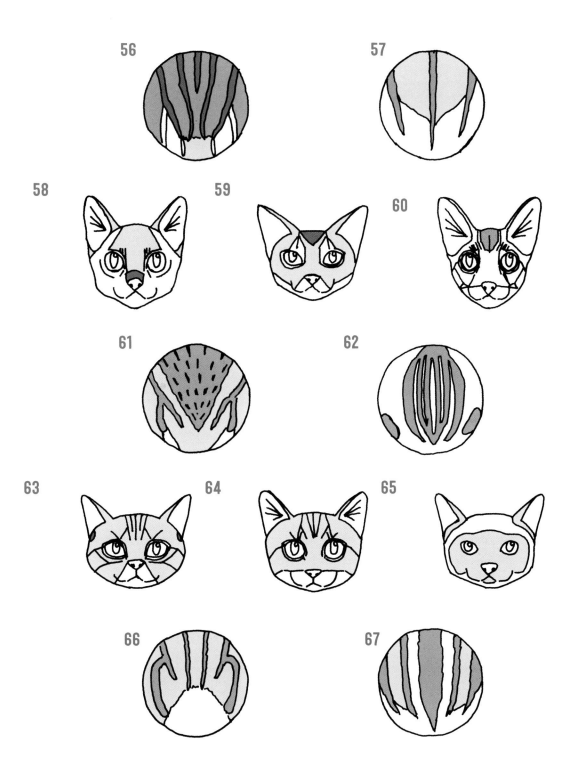

56 57 58 59 60 61 62 63 64 65 66 67

CAT ANTICS

photos: pages 12–13

■ ◯ = Number of strands ■ # = Color number ■ Fill with chain stitch ③ unless otherwise noted. Fill any gaps that are too small for chain stitch with satin or straight stitch. *(continued on next page)*

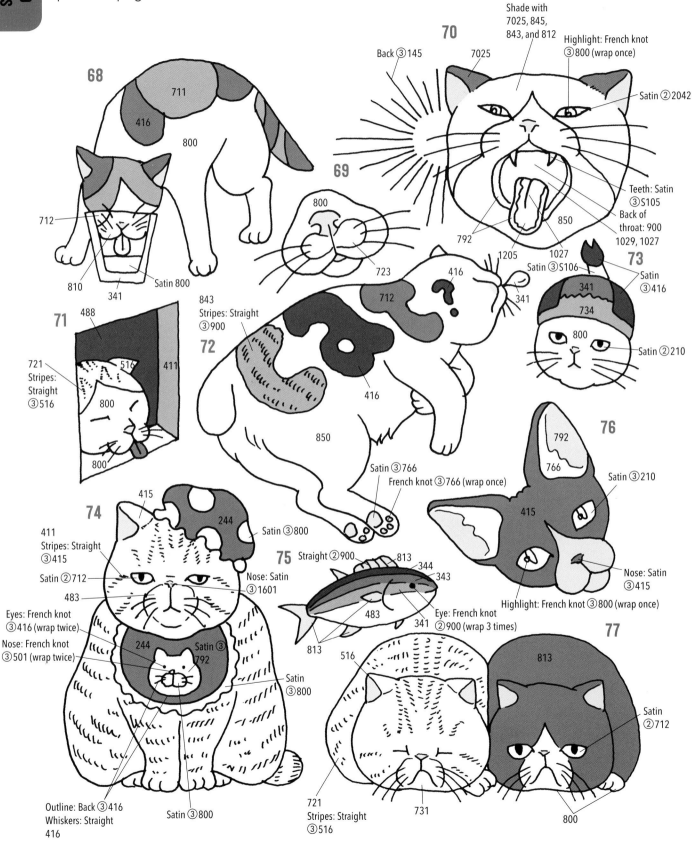

68
711
416
800
712
810
341
Satin 800

69
800
723

70
Back ③145
7025
Shade with 7025, 845, 843, and 812
Highlight: French knot ③800 (wrap once)
Satin ②2042
792
850
1205
1027
Satin ③S106
Teeth: Satin ③S105
Back of throat: 900
1029, 1027
416
712
341

71
721
Stripes: Straight ③516
488
516
411
800
800

72
843
Stripes: Straight ③900
416
850
Satin ③766
French knot ③766 (wrap once)

73
341
734
800
Satin ③416
Satin ②210

74
415
411
Stripes: Straight ③415
Satin ②712
483
Eyes: French knot ③416 (wrap twice)
Nose: French knot ③501 (wrap twice)
244
244
792
Satin ③800
Nose: Satin ③1601
Satin ③800
Outline: Back ③416
Whiskers: Straight 416
Satin ③800

75
Straight ②900
813
344
343
483
341
813
Eye: French knot ②900 (wrap 3 times)

76
792
766
Satin ③210
415
Nose: Satin ③415
Highlight: French knot ③800 (wrap once)

77
813
Satin ②712
516
721
Stripes: Straight ③516
731
800

■ Outline all motifs with chain stitch ②900 and use backstitch ②900 for thin outlines. ■ Noses and mouths are satin stitch ③766 unless otherwise noted. Ears are satin stitch ③792. Black eyes are satin stitch or straight stitch ③900. Tongues are satin stitch ③1205. Thick whiskers are backstitch ②416 and thin whiskers are straight stitch ①416.

■ ◯ = Number of strands ■ # = Color number ■ Fill with chain stitch ③ unless otherwise noted. Fill any gaps that are too small for chain stitch with satin or straight stitch. ■ Outline all motifs with chain stitch ②900 and use backstitch ②900 for thin outlines. *(continued on next page)*

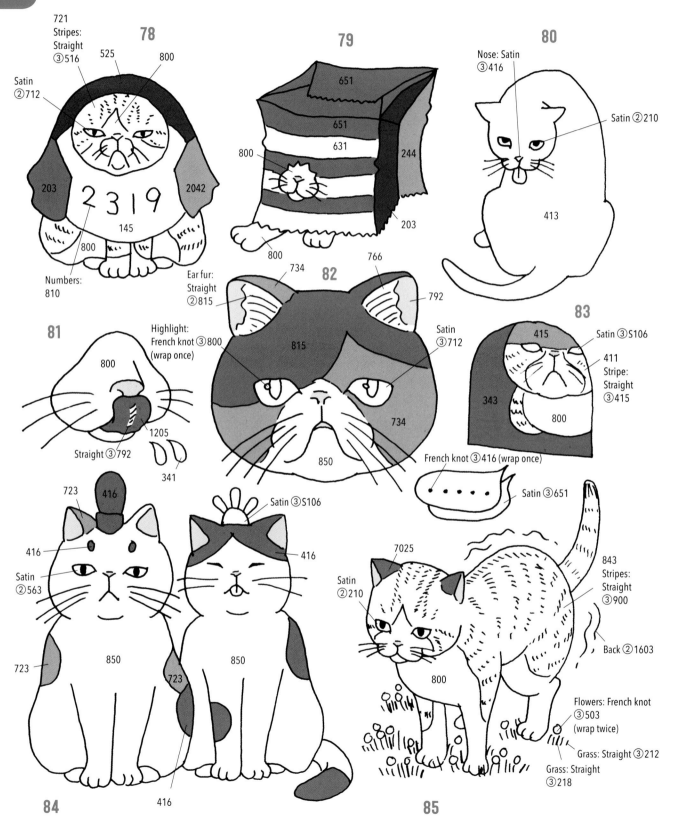

78
721
Stripes: Straight ③516
525
800
Satin ②712
203
2042
145
2 3 1 9
800
Numbers: 810

79
651
651
631
244
800
203
800

80
Nose: Satin ③416
Satin ②210
413

81
Ear fur: Straight ②815
Highlight: French knot ③800 (wrap once)
800
Straight ③792
1205
341

82
734
766
792
Satin ③712
815
734
850

83
415
Satin ③S106
411
Stripe: Straight ③415
343
800
French knot ③416 (wrap once)
Satin ③651

84
723
416
416
Satin ②563
416
723
850
850
723
416

85
7025
Satin ②210
800
843
Stripes: Straight ③900
Back ②1603
Flowers: French knot ③503 (wrap twice)
Grass: Straight ③212
Grass: Straight ③218

■ Noses and mouths are satin stitch ③766 unless otherwise noted. Ears are satin stitch ③792. Black eyes are satin or straight stitch ③900. Tongues are satin stitch ③1205. Thick whiskers are backstitch ②416 and thin whiskers are straight stitch ①416.

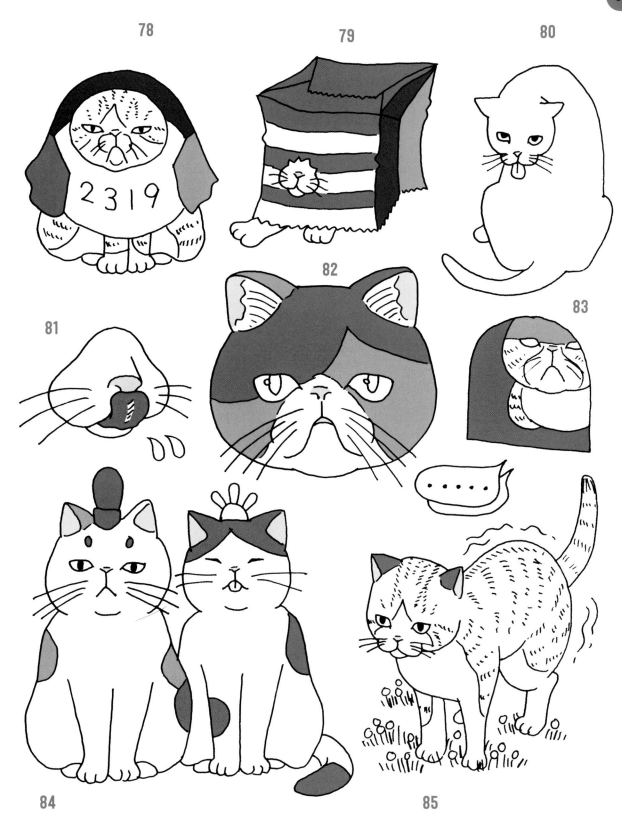

78

79

80

82

81

83

84

85

CHATTY CATS

photos: pages 14–15

■ ○ = Number of strands ■ # = Color number
■ Fill with chain stitch ③ unless otherwise noted.
Fill any gaps that are too small for chain stitch with
satin or straight stitch. *(continued on next page)*

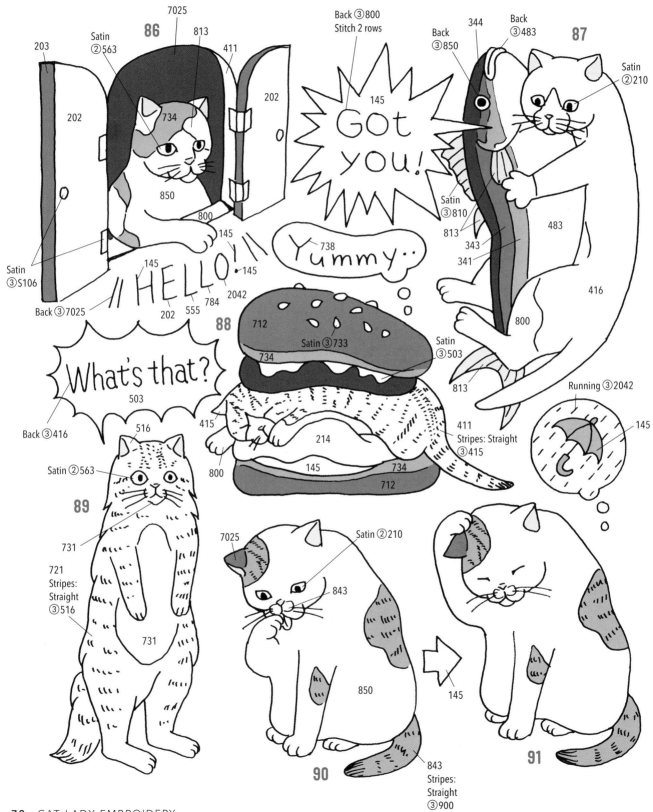

■ Outline all motifs with chain stitch ②900 and use backstitch ②900 for thin outlines. ■ Noses and mouths are satin stitch ③766 unless otherwise noted. Ears are satin stitch ③792. Black eyes are satin or straight stitch ③900. Tongues are satin stitch ③1205. Thick whiskers are backstitch ②416 and thin whiskers are straight stitch ①416. ■ Use French knots for the periods and exclamation points. Use the same thread color and number of strands as the rest of the text and wrap 3 times.

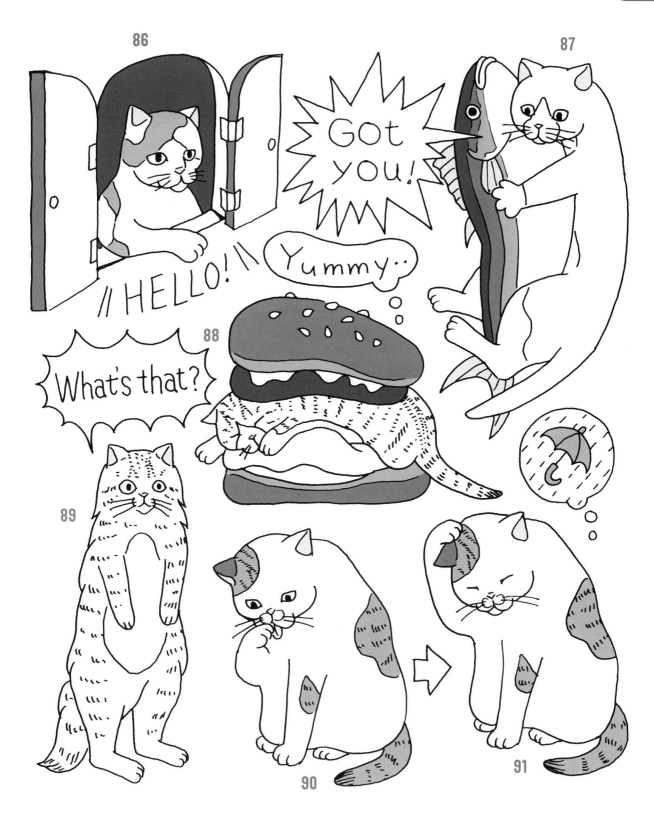

■ ◯ = Number of strands ■ # = Color number ■ Fill with chain stitch ③ unless otherwise noted. Fill any gaps that are too small for chain stitch with satin or straight stitch. ■ Outline all motifs with chain stitch ②900 and use backstitch ②900 for thin outlines. *(continued on next page)*

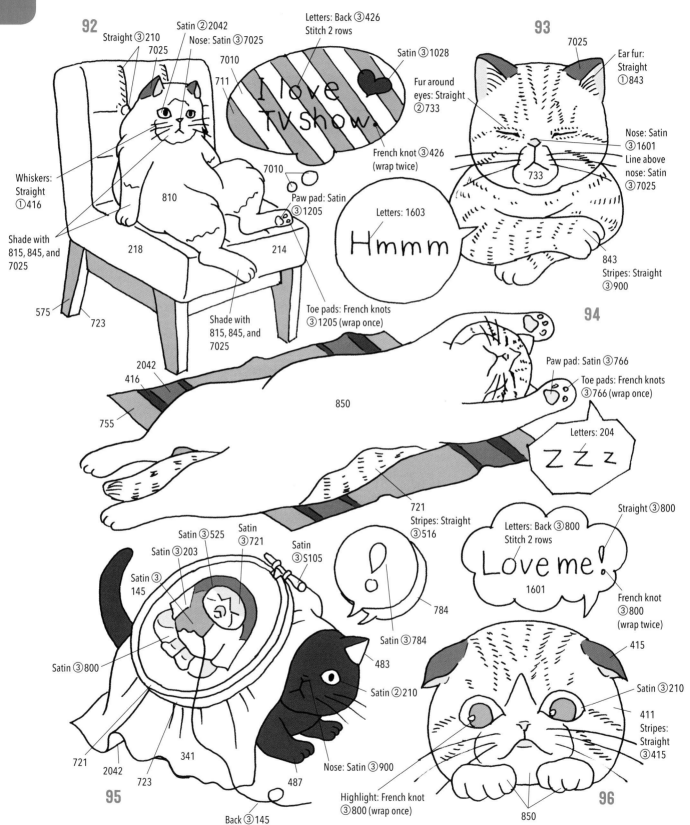

92

Straight ③210
7025
Satin ②2042
Nose: Satin ③7025
7010
711

Letters: Back ③426
Stitch 2 rows

Satin ③1028

Fur around eyes: Straight ②733

French knot ③426 (wrap twice)

Whiskers: Straight ①416

7010

Paw pad: Satin ③1205

810

Shade with 815, 845, and 7025

218

214

575
723

Shade with 815, 845, and 7025

Toe pads: French knots ③1205 (wrap once)

Letters: 1603

Hmmm

2042
416
755

850

93

7025

Ear fur: Straight ①843

Nose: Satin ③1601
Line above nose: Satin ③7025

733

843
Stripes: Straight ③900

94

Paw pad: Satin ③766

Toe pads: French knots ③766 (wrap once)

Letters: 204

Z Z z

721
Stripes: Straight ③516

Letters: Back ③800
Stitch 2 rows

Straight ③800

Love me!

1601

French knot ③800 (wrap twice)

Satin ③525
Satin ③721
Satin ③203
Satin ③S105
Satin ③145

!

784

Satin ③800

Satin ③784

483

Satin ②210

721
2042
723

341

487

Nose: Satin ③900

Back ③145

415

Satin ③210

411
Stripes: Straight ③415

Highlight: French knot ③800 (wrap once)

850

95

96

■ Noses and mouths are satin stitch ③766 unless otherwise noted. Ears are satin stitch ③792. Black eyes are satin or straight stitch ③900. Tongues are satin stitch ③1205. Thick whiskers are backstitch ②416 and thin whiskers are straight stitch ①416.

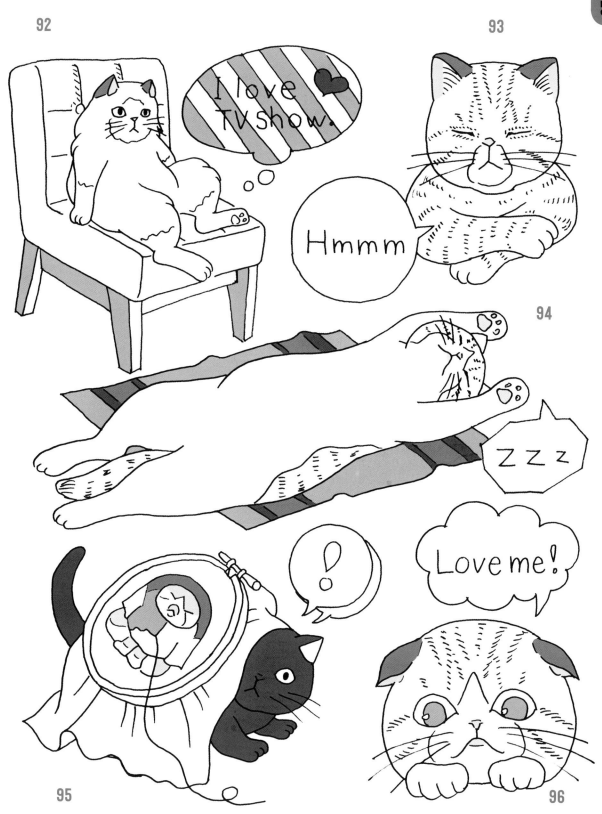

HOLIDAY CATS

photos: pages 16–17

■ ○ = Number of strands (use 2 strands unless otherwise noted) ■ # = Color number ■ Satin stitch unless otherwise noted.

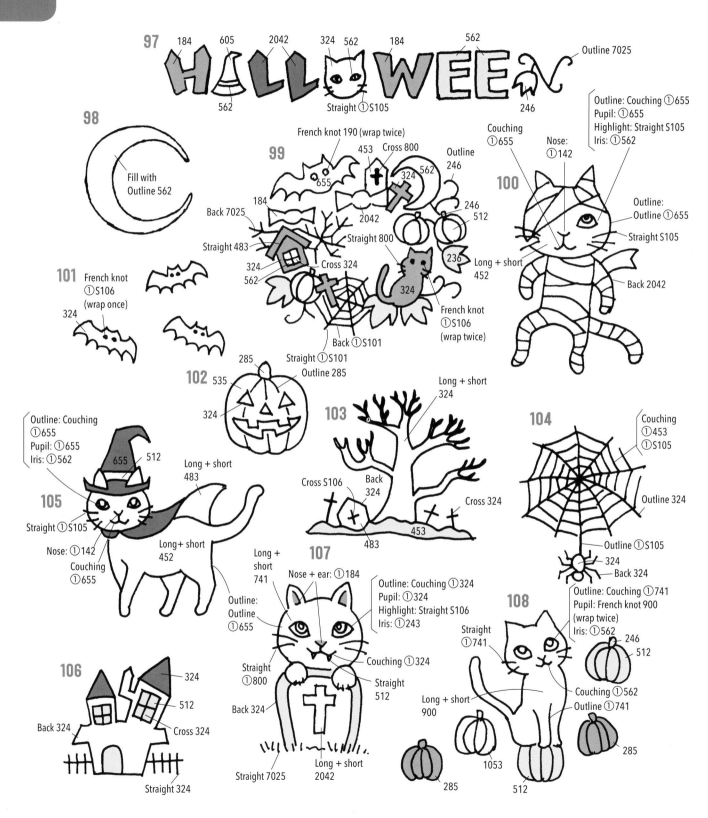

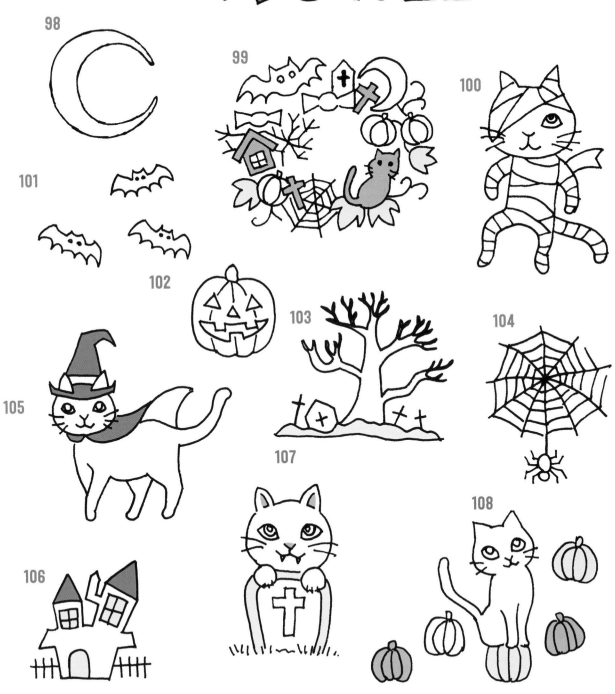

97 HALLOWEEN

98

99

100

101

102

103

104

105

106

107

108

■ ◯ = Number of strands (use 2 strands unless otherwise noted) ■ # = Color number ■ Satin stitch unless otherwise noted.

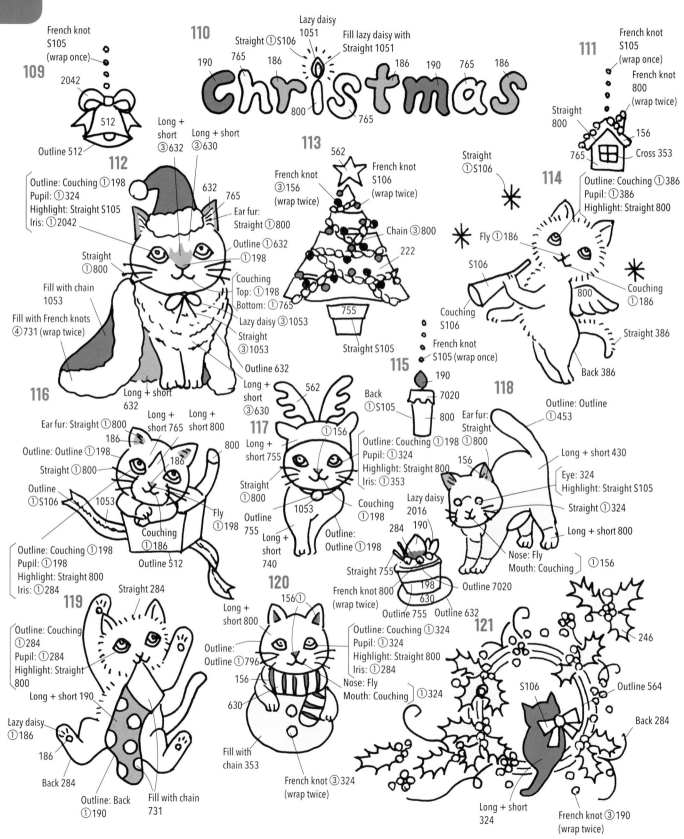

109

French knot S105 (wrap once)

2042

512

Outline 512

110

Lazy daisy 1051

Fill lazy daisy with Straight 1051

Straight ①S106

190 765 186

186 190 765 186

christmas

800 765

765

111

French knot S105 (wrap once)

French knot 800 (wrap twice)

Straight 800

156

765 Cross 353

112

Outline: Couching ①198
Pupil: ①324
Highlight: Straight S105
Iris: ①2042

Long + short ③632

Long + short ③630

632

765

Ear fur: Straight ①800

Outline ①632
①198

Straight ①800

Fill with chain 1053

Fill with French knots ④731 (wrap twice)

Couching
Top: ①198
Bottom: ①765

Lazy daisy ③1053

Straight ③1053

Outline 632

Long + short ③630

Long + short 632

113

562

French knot ③156 (wrap twice)

French knot S106 (wrap twice)

Chain ③800

222

755

Straight S105

114

Straight ①S106

Fly ①186

S106

Couching ①186

800

Straight 386

Back 386

115

Back ①S105

Couching S106

French knot S105 (wrap once)

190

7020

800

116

Ear fur: Straight ①800

Outline: Outline ①198

Straight ①800

Outline ①S106

186

Long + short 765

Long + short 800

800

186

186

1053

Outline: Couching ①198
Pupil: ①198
Highlight: Straight 800
Iris: ①284

Couching ①186

Outline 512

117

562

Long + short ③630

Long + short 755

Straight ①800

1053

Outline 755

Long + short 740

Fly ①198

118

Ear fur: Straight ①800

Outline: Outline ①453

Long + short 430

Eye: 324
Highlight: Straight S105

Straight ①324

Long + short 800

Nose: Fly
Mouth: Couching ①156

156

119

Outline: Couching ①284
Pupil: ①284
Highlight: Straight 800

Straight 284

Long + short 190

Lazy daisy ①186

186

Back 284

Outline: Back ①190

Fill with chain 731

120

Long + short 800

156①

Outline: Outline ①796

156

630

Fill with chain 353

French knot ③324 (wrap twice)

Outline: Couching ①324
Pupil: ①324
Highlight: Straight 800
Iris: ①284

Nose: Fly
Mouth: Couching ①324

Lazy daisy 2016

284 190

Straight 755

French knot 800 (wrap twice)

198
630

Outline 755 Outline 632

Outline 7020

Outline: Couching ①198
Pupil: ①324
Highlight: Straight 800
Iris: ①353

121

246

S106

Outline 564

Back 284

Long + short 324

French knot ③190 (wrap twice)

109

110

111

christmas

113

112

114

115

116

117

118

119

120

121

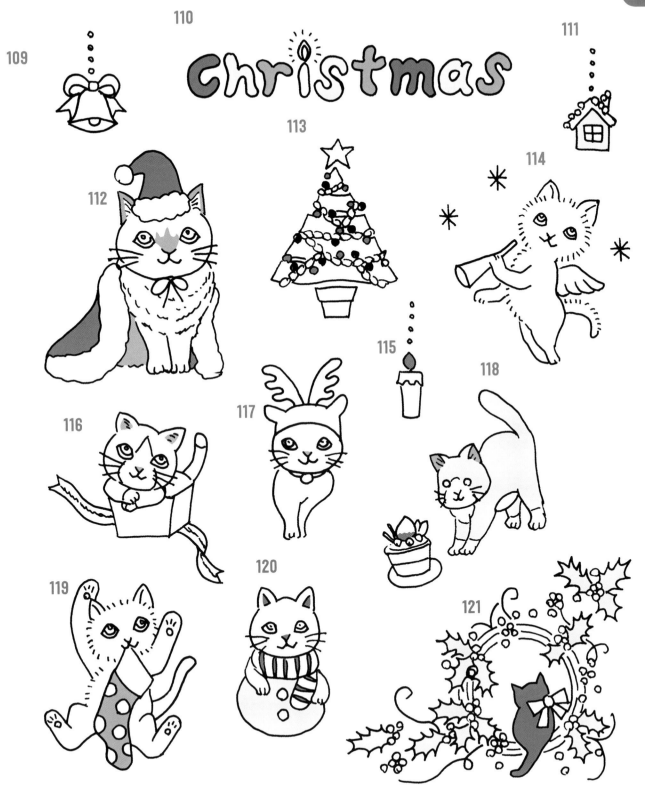

FLORA & FAUNA FELINES

photos: pages 18–19

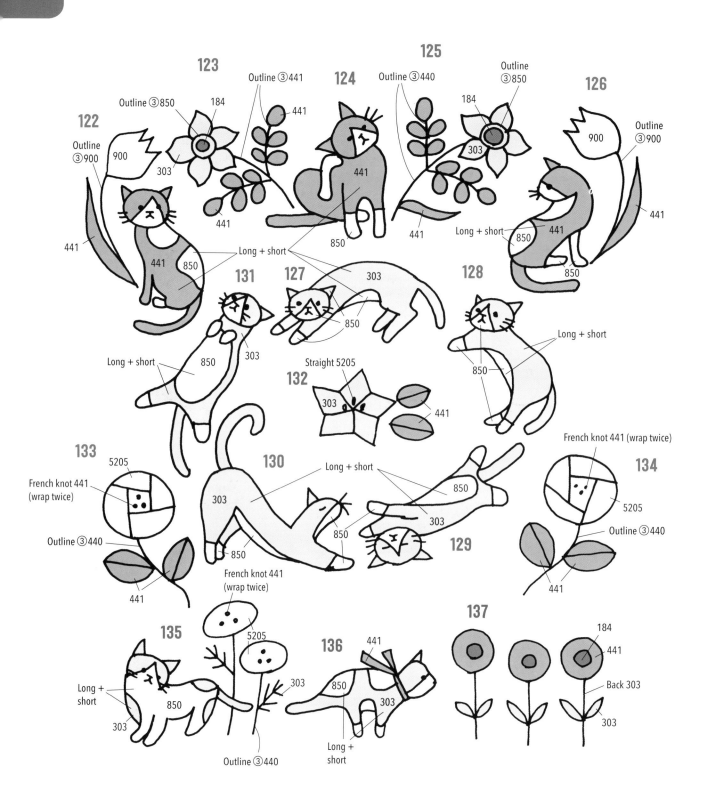

122
Outline ③900
900
441
441 850

123
Outline ③850
184
303
441
Outline ③441
441
441

124
441
850

125
Outline ③440
184
303
441

126
Outline ③850
900
Outline ③900
441
Long + short
850
850

131
Long + short
850
303

127
303
850
Long + short

128
Long + short
850

132
Straight 5205
303
441

133
5205
French knot 441 (wrap twice)
Outline ③440
441

130
303
Long + short
850
850
French knot 441 (wrap twice)
850

129
303
850

134
French knot 441 (wrap twice)
5205
Outline ③440
441

135
Long + short
303
850
French knot 441 (wrap twice)
5205
303
Outline ③440

136
441
850
303
Long + short

137
184
441
Back 303
303

■ ◯ = Number of strands (use 2 strands unless otherwise noted) ■ # = Color number ■ Satin stitch unless otherwise noted. ■ Whiskers, noses, and mouths are all straight stitch ①900. ■ Open eyes are French knot 900 (wrap twice). Closed eyes are straight stitch 900.

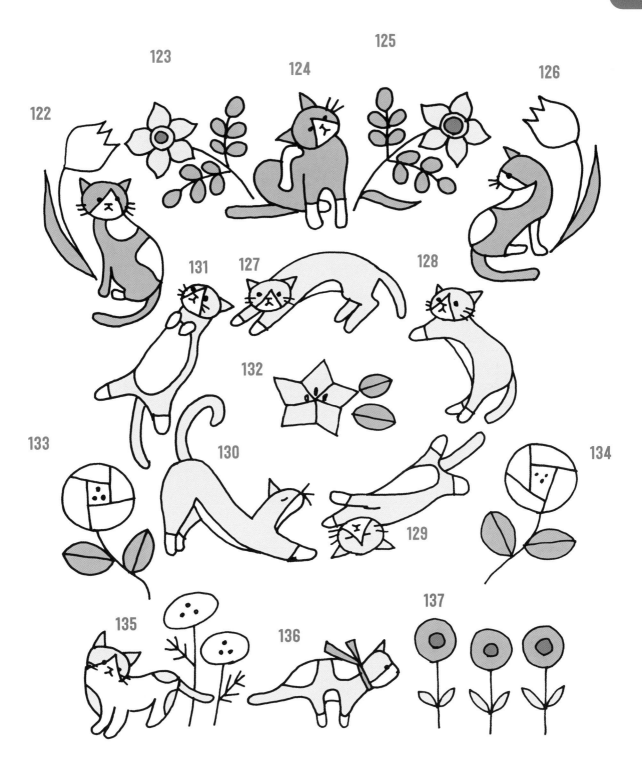

■ ◯ = Number of strands (use 2 strands unless otherwise noted) ■ # = Color number ■ Satin stitch unless otherwise noted. ■ Whiskers are straight stitch ①318 unless otherwise noted. ■ Eyes are French knot ③ (wrap twice).

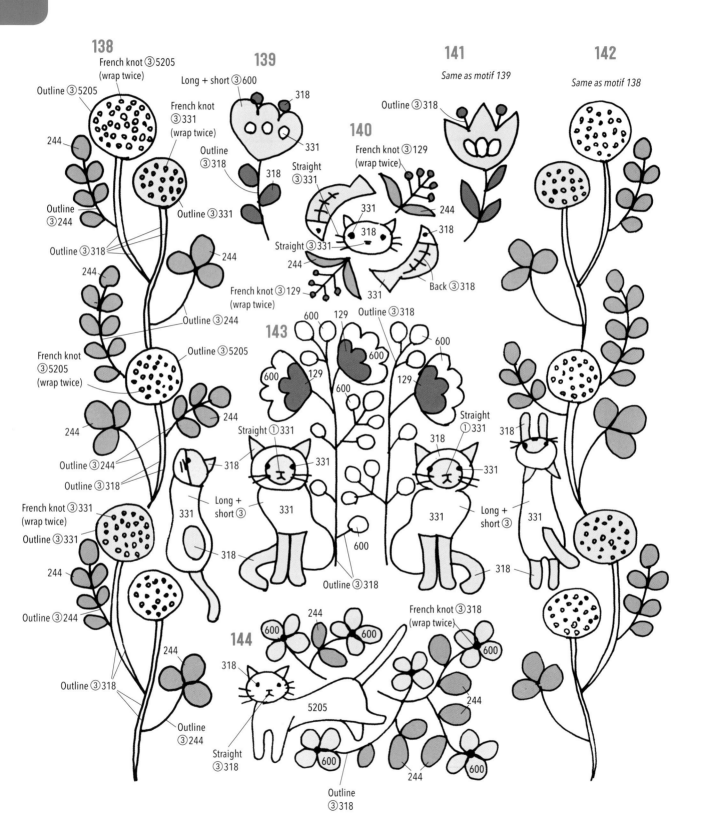

138
French knot ③5205 (wrap twice)
Outline ③5205
French knot ③331 (wrap twice)
244
Outline ③244
Outline ③318
Outline ③331
244
244
244
Outline ③244
French knot ③5205 (wrap twice)
Outline ③5205
244
244
Outline ③244
Outline ③318
French knot ③331 (wrap twice)
Outline ③331
244
244
Outline ③244
244
Outline ③318
Outline ③244

139
Long + short ③600
318
331
Outline ③318
318

140
French knot ③129 (wrap twice)
Straight ③331
331
244
318
Straight ③331
244
Back ③318
331
French knot ③129 (wrap twice)

141
Same as motif 139
Outline ③318

142
Same as motif 138

143
600
129
600
Outline ③318
600
600
129
129
600
Straight ①331
318
Straight ①331
318
331
331
Long + short ③
331
318
600
331
Long + short ③
331
318
Outline ③318
318

144
French knot ③318 (wrap twice)
600
244
600
318
5205
600
244
600
244
244
600
Straight ③318
Outline ③318

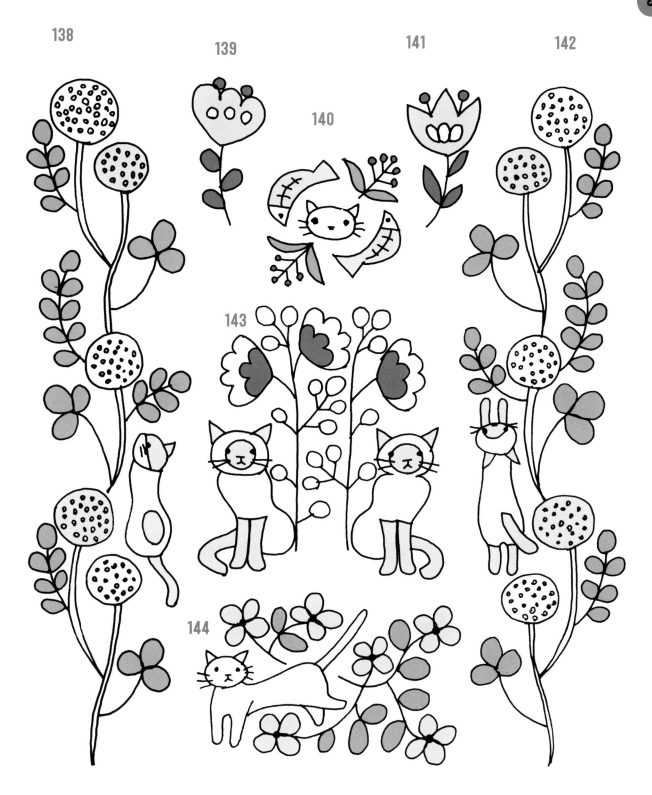

138

139

141

142

140

143

144

PAMPERED PUSSYCATS

photos: pages 20–21

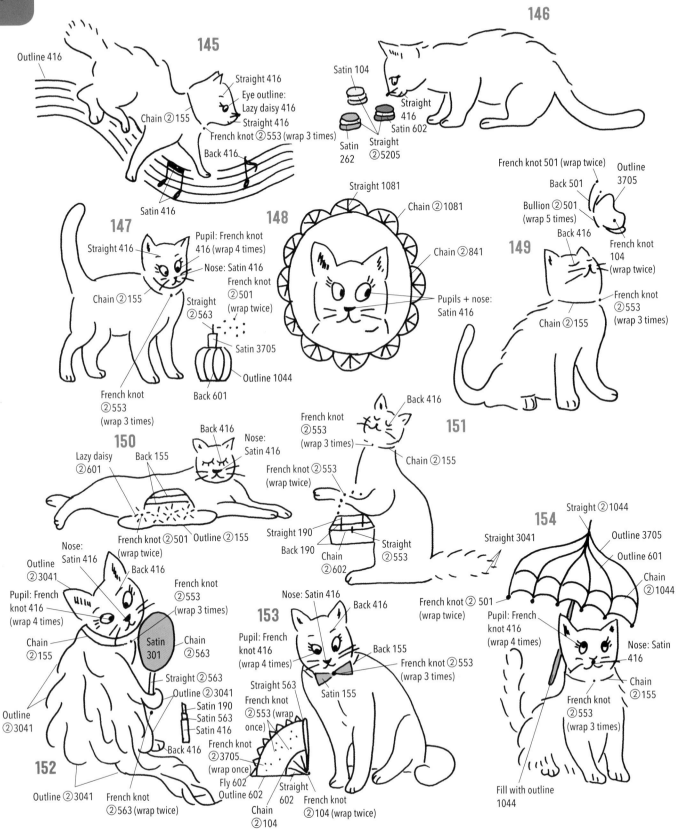

145

Outline 416

Chain ②155

Straight 416

Eye outline:
Lazy daisy 416

Straight 416

French knot ②553 (wrap 3 times)

Back 416

Satin 416

146

Satin 104

Straight 416

Satin 602

Satin 262

Straight ②5205

147

Straight 416

Pupil: French knot 416 (wrap 4 times)

Nose: Satin 416

French knot ②501 (wrap twice)

Chain ②155

Straight ②563

Satin 3705

Outline 1044

Back 601

French knot ②553 (wrap 3 times)

148

Straight 1081

Chain ②1081

Chain ②841

Pupils + nose: Satin 416

149

French knot 501 (wrap twice)

Outline 3705

Back 501

Bullion ②501 (wrap 5 times)

Back 416

French knot 104 (wrap twice)

French knot ②553 (wrap 3 times)

Chain ②155

150

Lazy daisy ②601

Back 155

Back 416

Nose: Satin 416

French knot ②501 (wrap twice)

Outline ②155

151

Back 416

French knot ②553 (wrap 3 times)

French knot ②553 (wrap twice)

Chain ②155

Straight 190

Back 190

Chain ②602

Straight ②553

152

Nose: Satin 416

Outline ②3041

Back 416

French knot ②553 (wrap 3 times)

Pupil: French knot 416 (wrap 4 times)

Chain ②155

Satin 301

Chain ②563

Outline ②3041

Straight ②563

Outline ②3041

Satin 190

Satin 563

Satin 416

Back 416

Outline ②3041

French knot ②563 (wrap twice)

153

Nose: Satin 416

Back 416

Pupil: French knot 416 (wrap 4 times)

Back 155

French knot ②553 (wrap 3 times)

Satin 155

Straight 563

French knot ②553 (wrap once)

French knot ②3705 (wrap once)

Fly 602

Outline 602

Straight 602

Chain ②104

French knot ②104 (wrap twice)

154

Straight ②1044

Outline 3705

Outline 601

Chain ②1044

Straight 3041

French knot ② 501 (wrap twice)

Pupil: French knot 416 (wrap 4 times)

Nose: Satin 416

Chain ②155

French knot ②553 (wrap 3 times)

Fill with outline 1044

■ ◯ = Number of strands (use 1 strand unless otherwise noted) ■ # = Color number ■ Outlines are outline stitch 3041 ■ Inner ears are straight stitch 163. ■ Eyelashes and whiskers are straight stitch 416. ■ Claws are straight stitch 488. ■ Eye outlines are backstitch 416 unless otherwise noted. ■ Noses are French knot 416 (wrap twice) unless otherwise noted. ■ Mouths are backstitch 416 unless otherwise noted.

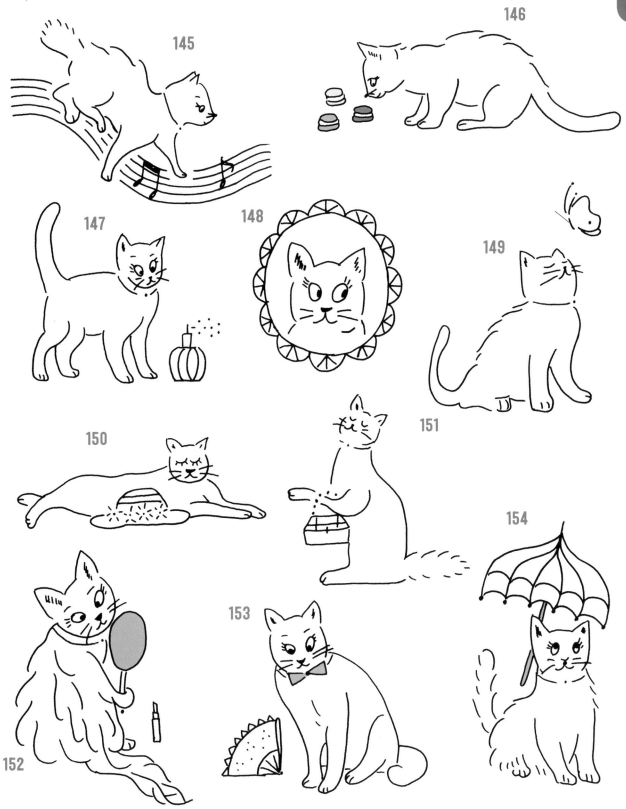

■ ◯ = Number of strands (use 1 strand unless otherwise noted) ■ # = Color number ■ Outlines are outline stitch 3041 ■ Inner ears are straight stitch 163. ■ Eyelashes and whiskers are straight stitch 416. ■ Claws are straight stitch 488. ■ Pupils are satin stitch 416. *(continued on next page)*

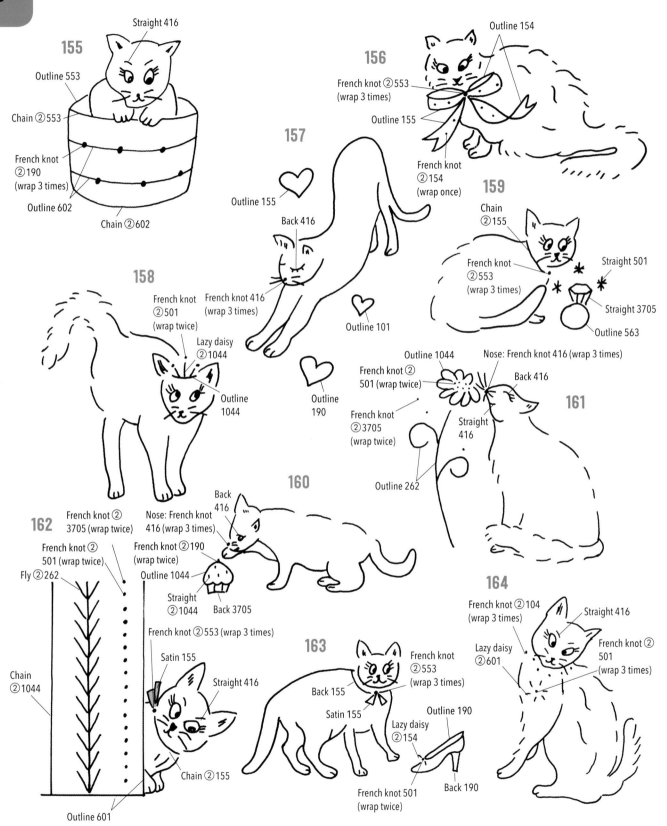

155
Straight 416
Outline 553
Chain ②553
French knot ②190 (wrap 3 times)
Outline 602
Chain ②602

156
Outline 154
French knot ②553 (wrap 3 times)
Outline 155
French knot ②154 (wrap once)

157
Outline 155
Back 416
French knot 416 (wrap 3 times)
Outline 101
Outline 190

158
French knot ②501 (wrap twice)
Lazy daisy ②1044
Outline 1044
French knot 416 (wrap 3 times)

159
Chain ②155
French knot ②553 (wrap 3 times)
Straight 501
Straight 3705
Outline 563

161
Outline 1044
French knot ② 501 (wrap twice)
French knot ②3705 (wrap twice)
Nose: French knot 416 (wrap 3 times)
Back 416
Straight 416
Outline 262

160
Back 416
Nose: French knot 416 (wrap 3 times)
French knot ②190 (wrap twice)
Outline 1044
Straight ②1044
Back 3705

162
French knot ② 3705 (wrap twice)
French knot ② 501 (wrap twice)
Fly ②262
Chain ②1044
French knot ②553 (wrap 3 times)
Satin 155
Straight 416
Chain ②155
Outline 601

163
French knot ②553 (wrap 3 times)
Back 155
Satin 155
Lazy daisy ②154
French knot 501 (wrap twice)
Outline 190
Back 190

164
French knot ②104 (wrap 3 times)
Straight 416
Lazy daisy ②601
French knot ② 501 (wrap 3 times)

■ Eye outlines are backstitch 416 unless otherwise noted. ■ Noses are satin 416 unless otherwise noted. ■ Mouths are backstitch 416 unless otherwise noted.

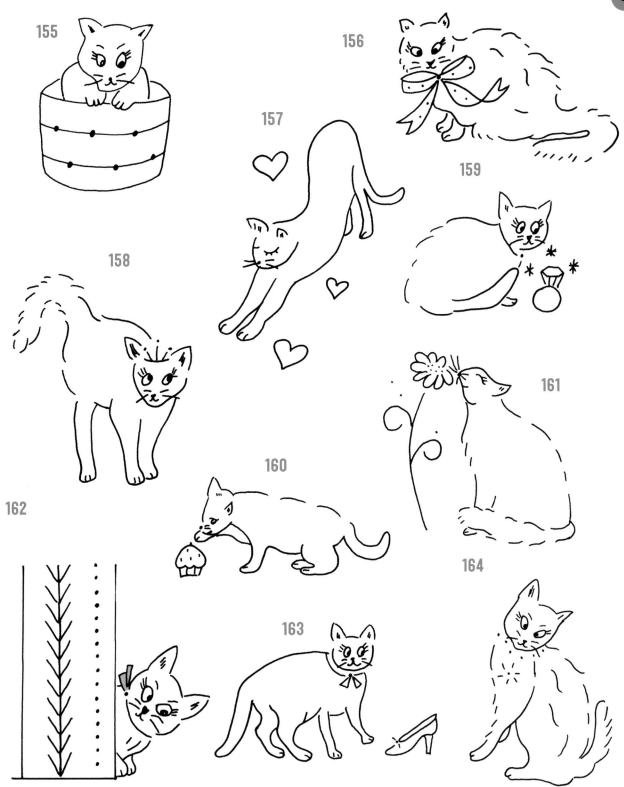

155

156

157

159

158

161

162

160

164

163

EVERYDAY SHENANIGANS

photos: pages 22–23

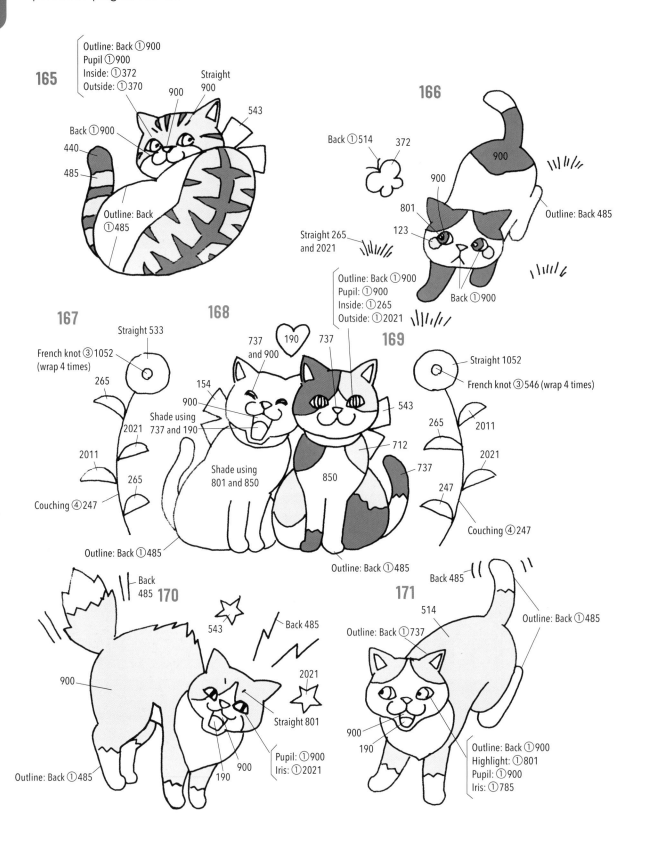

165

Outline: Back ①900
Pupil ①900
Inside: ①372
Outside: ①370

900

Straight 900

543

Back ①900

440

485

Outline: Back
①485

166

Back ①514

372

900

900

801

123

Outline: Back 485

Straight 265
and 2021

Outline: Back ①900
Pupil: ①900
Inside: ①265
Outside: ①2021

Back ①900

167

Straight 533

French knot ③1052
(wrap 4 times)

265

2021

2011

265

Couching ④247

168

737
and 900

190

737

154

900

Shade using
737 and 190

Shade using
801 and 850

Outline: Back ①485

169

543

712

850

737

Straight 1052

French knot ③546 (wrap 4 times)

265

2011

2021

247

Couching ④247

Outline: Back ①485

170

Back
485

543

Back 485

2021

Straight 801

900

900

190

900

Pupil: ①900
Iris: ①2021

Outline: Back ①485

171

Back 485

514

Outline: Back ①737

Outline: Back ①485

900

190

Outline: Back ①900
Highlight: ①801
Pupil: ①900
Iris: ①785

■ ◯ = Number of strands (use 2 strands unless otherwise noted) ■ # = Color number ■ Use long and short stitch unless otherwise noted. ■ Ears and noses are 123 unless otherwise noted.

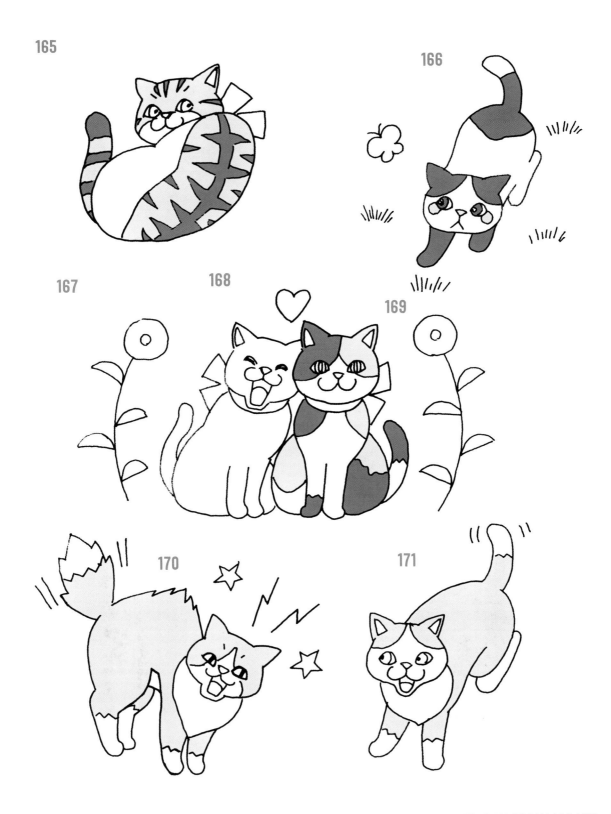

165

166

167

168

169

170

171

■ ○ = Number of strands (use 2 strands unless otherwise noted) ■ # = Color number ■ Use long and short stitch unless otherwise noted.

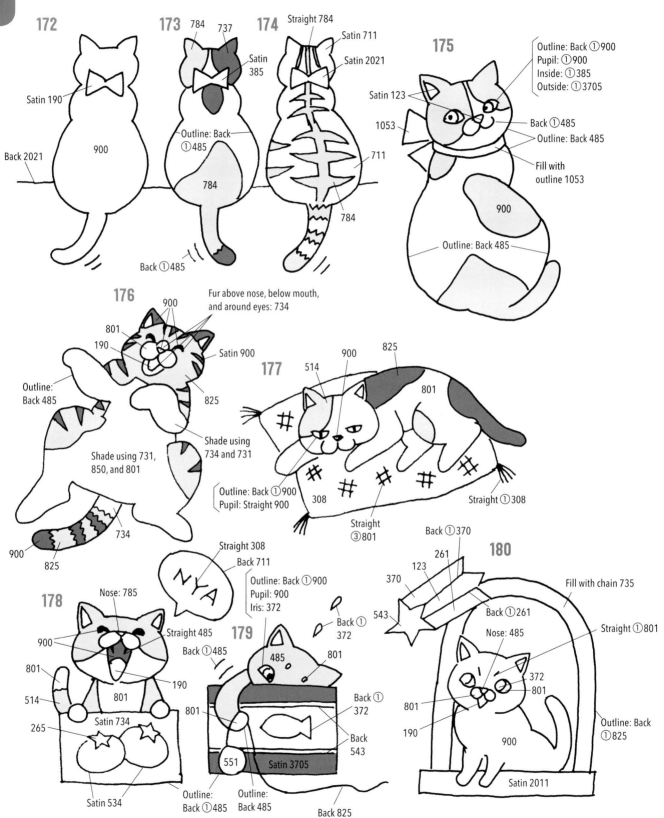

172
Satin 190
Back 2021
900

173
784
737
Satin 385
Outline: Back ①485
784
Back ①485

174
Straight 784
Satin 711
Satin 2021
711
784

175
Satin 123
1053
Outline: Back ①900
Pupil: ①900
Inside: ①385
Outside: ①3705
Back ①485
Outline: Back 485
Fill with outline 1053
900
Outline: Back 485

176
900
801
190
Fur above nose, below mouth, and around eyes: 734
Satin 900
825
Shade using 734 and 731
Outline: Back 485
Shade using 731, 850, and 801
734
900
825

177
514
900
825
801
308
Outline: Back ①900
Pupil: Straight 900
Straight ③801
Straight ①308

178
Nose: 785
900
Straight 485
801
514
801
265
Satin 734
Satin 534

179
Straight 308
Back 711
Outline: Back ①900
Pupil: 900
Iris: 372
Back ①485
485
801
Back ① 372
801
Back ① 372
Back 543
551
Satin 3705
Outline: Back ①485
Outline: Back 485
Back 825

180
Back ①370
261
370
123
543
Back ①261
Nose: 485
372
801
801
190
900
Fill with chain 735
Straight ①801
Outline: Back ①825
Satin 2011

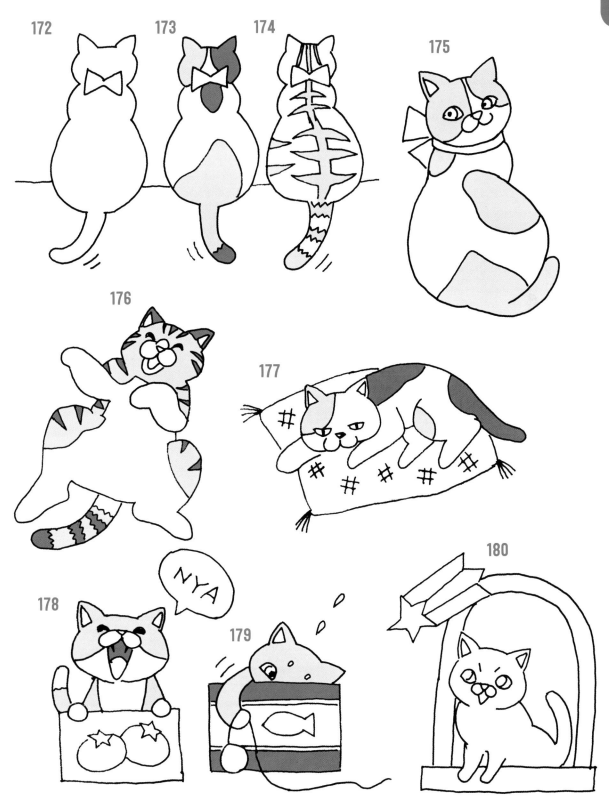

CAT CHARACTERS

photos: pages 24–25

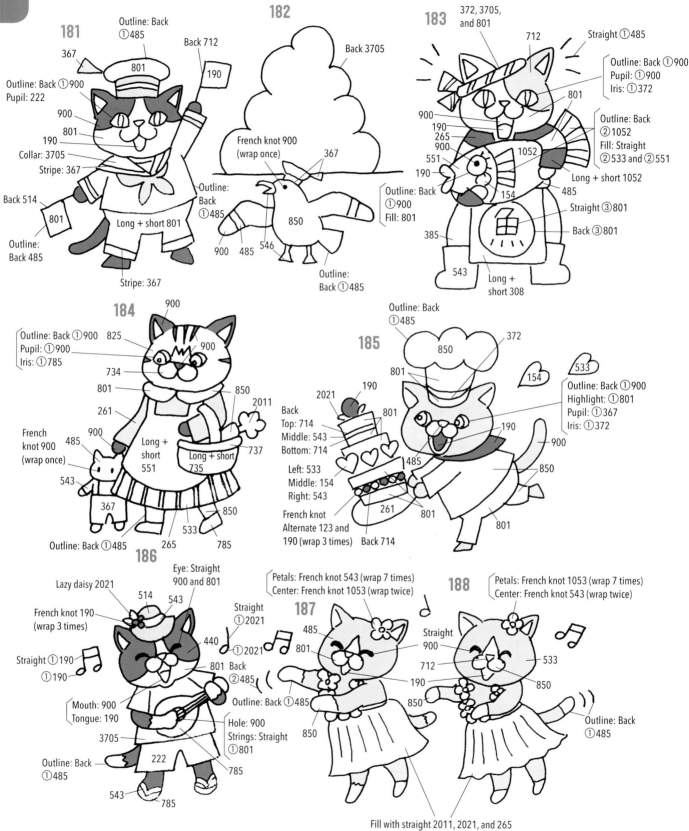

181

Outline: Back ①485

367

Back 712

190

Outline: Back ①900
Pupil: 222

801

900

801

190

Collar: 3705

Stripe: 367

Back 514

801

Outline: Back 485

Long + short 801

Stripe: 367

182

Back 3705

French knot 900 (wrap once)

367

Outline: Back ①485

900 485 546

850

Outline: Back ①485

183

372, 3705, and 801

712

Straight ①485

Outline: Back ①900
Pupil: ①900
Iris: ①372

900

190
265
900
551
190

801

1052

Outline: Back ②1052
Fill: Straight ②533 and ②551

Long + short 1052

485

154

Straight ③801

Back ③801

385

543

Long + short 308

184

900

825

Outline: Back ①900
Pupil: ①900
Iris: ①785

734

801

261

900

French knot 900 (wrap once)

485

543

367

Outline: Back ①485

265

533

785

850

2011

Long + short 551

Long + short 735

737

850

185

Outline: Back ①485

850

372

801

154

533

Outline: Back ①900
Highlight: ①801
Pupil: ①367
Iris: ①372

190

801

190

900

850

485

261

801

801

Back
Top: 714
Middle: 543
Bottom: 714

Left: 533
Middle: 154
Right: 543

French knot Alternate 123 and 190 (wrap 3 times)

Back 714

2021

190

186

Lazy daisy 2021

514

543

Eye: Straight 900 and 801

French knot 190 (wrap 3 times)

Straight ①190
①190

440

Straight ①2021
①2021

801 Back ②485

Outline: Back ①485

Hole: 900
Strings: Straight ①801

Mouth: 900
Tongue: 190

3705

222

785

Outline: Back ①485

543

785

187

Petals: French knot 543 (wrap 7 times)
Center: French knot 1053 (wrap twice)

485

801

Straight 900

190

850

850

188

Petals: French knot 1053 (wrap 7 times)
Center: French knot 543 (wrap twice)

Straight 900

712

533

850

Outline: Back ①485

Fill with straight 2011, 2021, and 265

■ ○ = Number of strands (use 2 strands unless otherwise noted) ■ # = Color number ■ Use satin stitch unless otherwise noted. ■ Ears and noses are 123 unless otherwise noted.

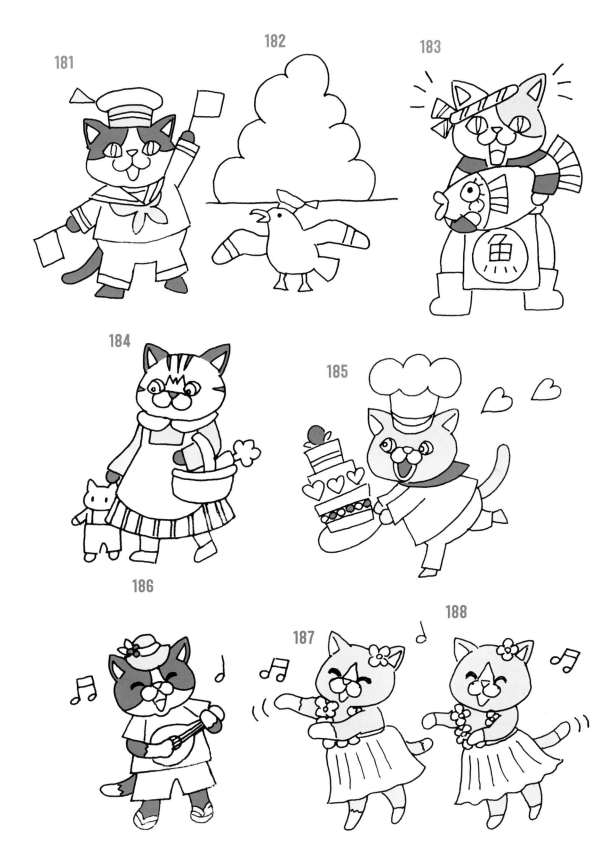

181

182

183

184

185

186

187

188

■ ◯ = Number of strands (use 2 strands unless otherwise noted) ■ # = Color number ■ Use satin stitch unless otherwise noted.

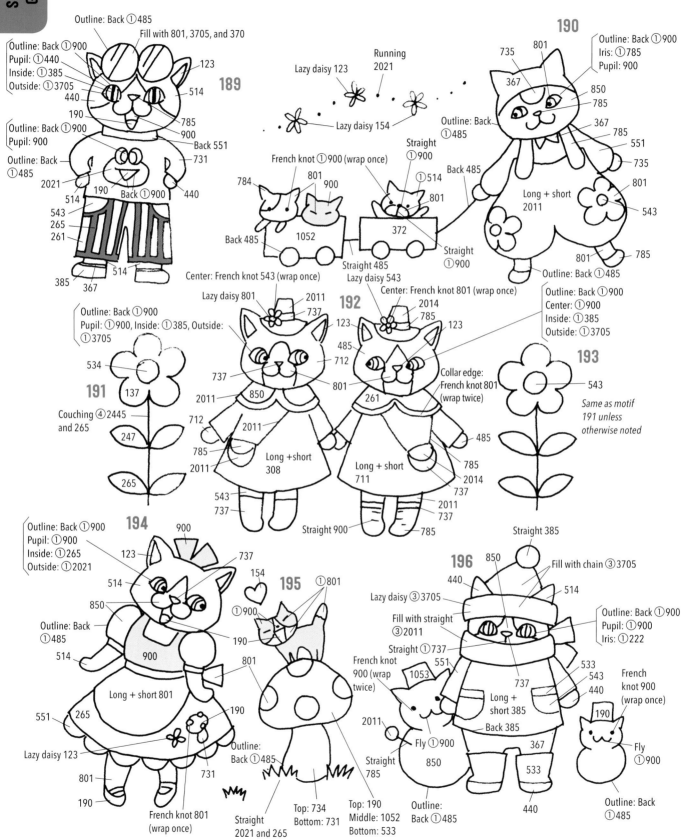

189

Outline: Back ①485
Fill with 801, 3705, and 370
Outline: Back ①900
Pupil: ①440
Inside: ①385
Outside: ①3705
123
440
514
190
785
Outline: Back ①900
Pupil: 900
900
Back 551
Outline: Back ①485
731
2021
190
514
Back ①900
440
543
265
261
514
385
367

Running 2021
Lazy daisy 123
Lazy daisy 154

French knot ①900 (wrap once)
784
801
900
①514
Straight ①900
801
Back 485
1052
372
Straight ①900
Back 485
Straight 485

190
735
801
Outline: Back ①900
Iris: ①785
Pupil: 900
367
850
785
367
785
551
735
Outline: Back ①485
Long + short 2011
801
543
801
785
Outline: Back ①485

Lazy daisy 801
Center: French knot 543 (wrap once)
2011
737
123
485
712
737
850
801
2011
712
785
2011
543
737
Long +short 308
Straight 900

192
Lazy daisy 543
Center: French knot 801 (wrap once)
2014
785
123
261
Collar edge: French knot 801 (wrap twice)
485
785
2014
737
2011
737
785

Outline: Back ①900
Center: ①900
Inside: ①385
Outside: ①3705

193
543
Same as motif 191 unless otherwise noted

Outline: Back ①900
Pupil: ①900, Inside: ①385, Outside: ①3705
534
191
137
Couching ④2445 and 265
247
265

194
900
Outline: Back ①900
Pupil: ①900
Inside: ①265
Outside: ①2021
123
737
514
154
850
Outline: Back ①485
514
900
Long + short 801
551
265
190
Lazy daisy 123
801
190
731
French knot 801 (wrap once)

195
①801
①900
190
801
Outline: Back ①485
Straight 2021 and 265
Top: 734
Bottom: 731
Top: 190
Middle: 1052
Bottom: 533

196
Straight 385
850
440
Fill with chain ③3705
514
Lazy daisy ③3705
Fill with straight ③2011
Outline: Back ①900
Pupil: ①900
Iris: ①222
Straight ①737
551
1053
533
543
440
737
French knot 900 (wrap twice)
French knot 900 (wrap once)
2011
Long + short 385
Back 385
190
Fly ①900
850
367
533
Fly ①900
Straight 785
Outline: Back ①485
440
Outline: Back ①485

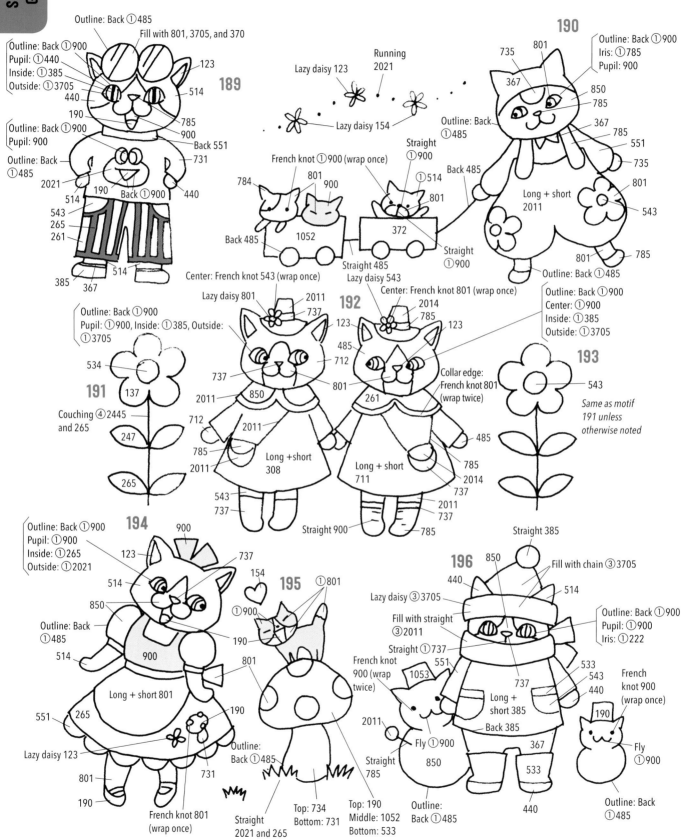

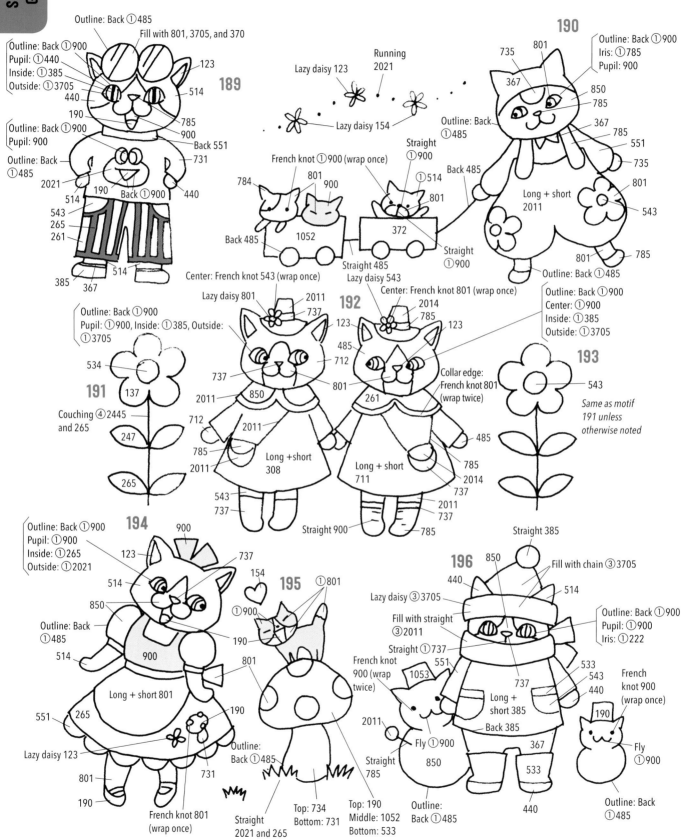
French knot 900 (wrap two)
Straight 785

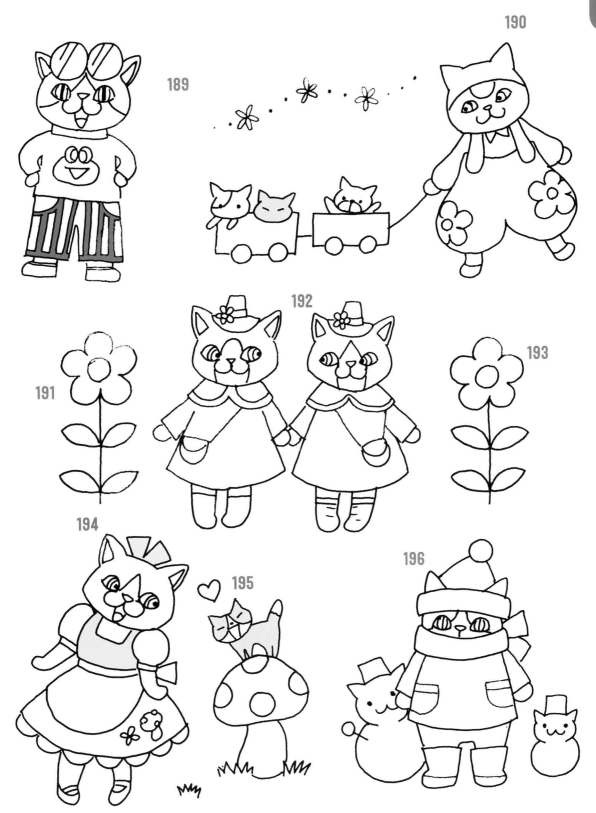

189
190
191
192
193
194
195
196

FAST FRIENDS

photos: pages 26–27

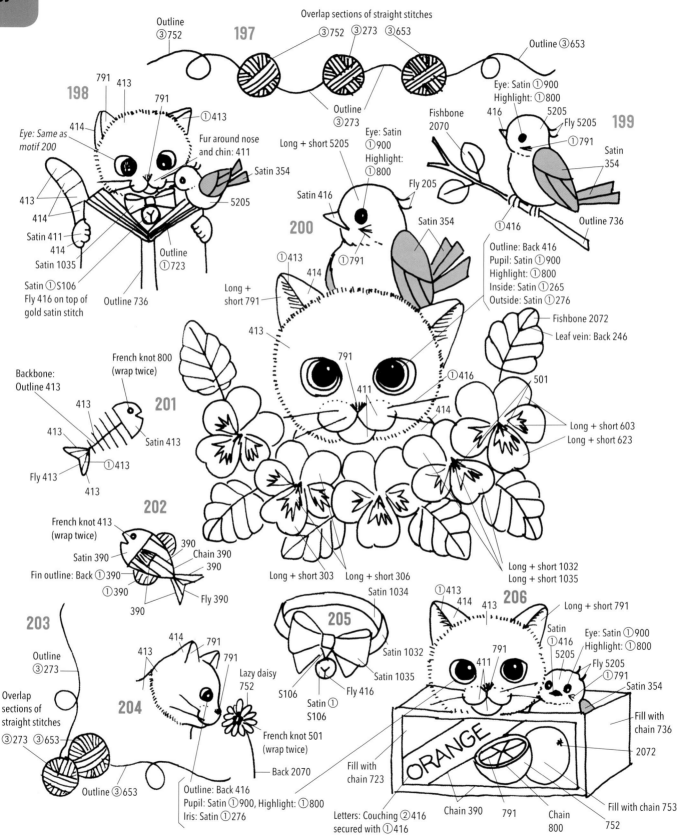

197 Outline ③752

Overlap sections of straight stitches
③752 ③273 ③653

Outline ③653

Outline ③273

198
791
413
791
①413
Eye: Same as motif 200
414
Fur around nose and chin: 411
Satin 354
413
5205
414
Satin 411
414
Satin 1035
Satin ①S106
Fly 416 on top of gold satin stitch
Outline 736
Outline ①723

Long + short 5205
Eye: Satin ①900
Highlight: ①800
Satin 416
Fly 205
200
①413
414
Satin 354
①791
Long + short 791
413

Fishbone 2070
Eye: Satin ①900
Highlight: ①800
416
5205
5205
Fly 5205
①791
199
Satin 354
①416
Outline: Back 416
Pupil: Satin ①900
Highlight: ①800
Inside: Satin ①265
Outside: Satin ①276
Outline 736

Fishbone 2072
Leaf vein: Back 246

791
411
①416
414
501
Long + short 603
Long + short 623

Backbone: Outline 413
French knot 800 (wrap twice)
201
413
413
413
Satin 413
①413
Fly 413
413

French knot 413 (wrap twice)
202
Satin 390
390
Chain 390
390
Fin outline: Back ①390
①390
Fly 390
390

Long + short 303
Long + short 306
Long + short 1032
Long + short 1035

203
Outline ③273
Overlap sections of straight stitches
③273 ③653
Outline ③653

414
791
413
791
204
Lazy daisy 752
French knot 501 (wrap twice)
Back 2070
Outline: Back 416
Pupil: Satin ①900, Highlight: ①800
Iris: Satin ①276

205
Satin 1034
Satin 1032
S106
Satin ① S106
Fly 416
Satin 1035

①413
414
413
206
Long + short 791
Satin
①416
5205
Eye: Satin ①900
Highlight: ①800
791
411
Fly 5205
①791
Satin 354
Fill with chain 736
2072
Fill with chain 723
ORANGE
Letters: Couching ②416 secured with ①416
Chain 390
791
Chain 800
752
Fill with chain 753

■ ◯ = Number of strands (use 2 strands unless otherwise noted) ■ # = Color number ■ Use straight stitch unless otherwise noted. ■ Fill the cat fur and bird feathers with short straight stitches unless otherwise noted. ■ Cat whiskers are straight stitch ①416 and mouths are outline stitch ②416.

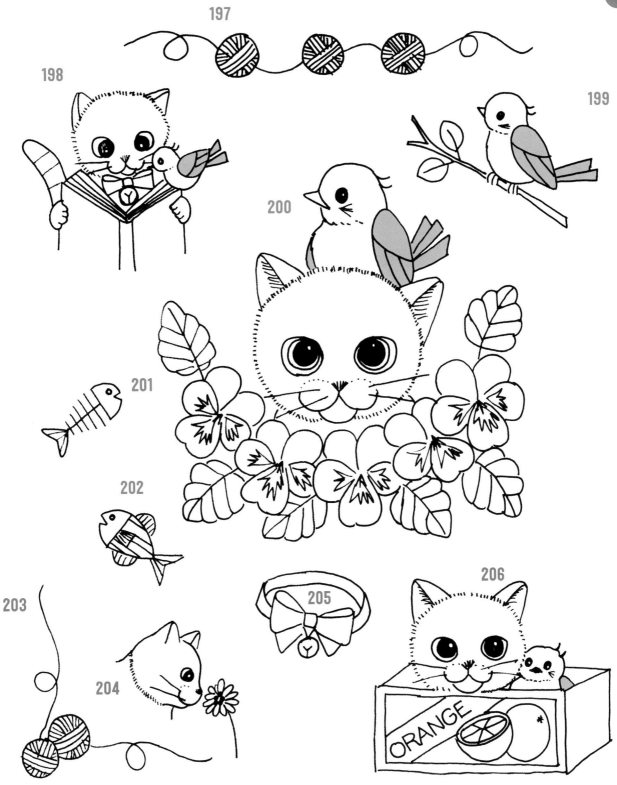

■ ◯ = Number of strands (use 2 strands unless otherwise noted) ■ # = Color number ■ Use straight stitch unless otherwise noted. *(continued on next page)*

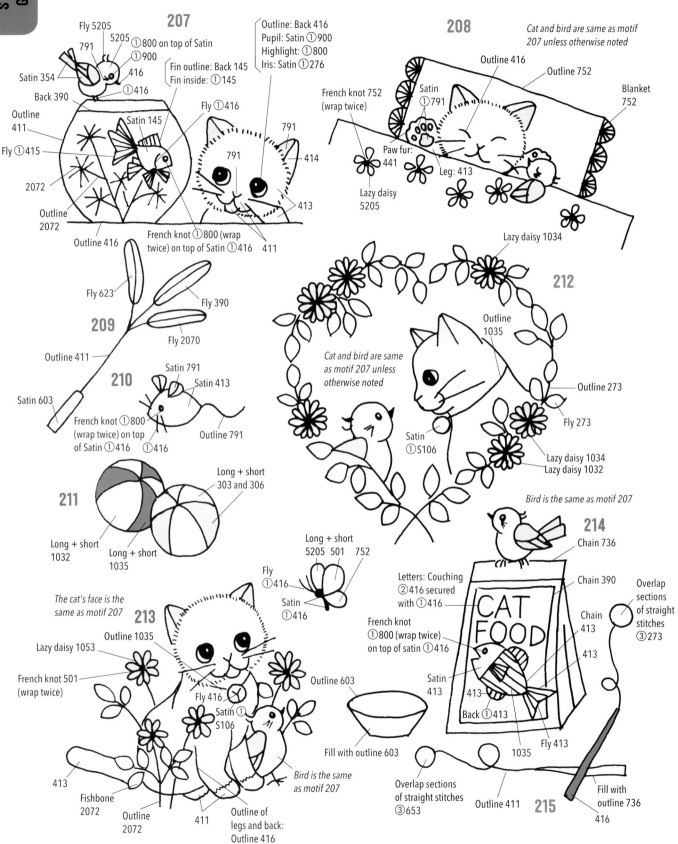

207

Fly 5205
5205
791
Satin 354
Back 390
Outline 411
Fly ①415
2072
Outline 2072
Outline 416
①800 on top of Satin
①900
416
①416
Fin outline: Back 145
Fin inside: ①145
Fly ①416
Satin 145
791
791
414
413
411
French knot ①800 (wrap twice) on top of Satin ①416

Outline: Back 416
Pupil: Satin ①900
Highlight: ①800
Iris: Satin ①276

208

Cat and bird are same as motif 207 unless otherwise noted

Outline 416
Outline 752
Blanket 752
French knot 752 (wrap twice)
Satin ①791
Paw fur: 441
Leg: 413
Lazy daisy 5205

209

Fly 623
Fly 390
Fly 2070
Outline 411

210

Satin 603
Satin 791
Satin 413
French knot ①800 (wrap twice) on top of Satin ①416 ①416
Outline 791

212

Lazy daisy 1034
Outline 1035
Outline 273
Fly 273
Cat and bird are same as motif 207 unless otherwise noted
Satin ①S106
Lazy daisy 1034
Lazy daisy 1032

211

Long + short 303 and 306
Long + short 1032
Long + short 1035

213

The cat's face is the same as motif 207
Lazy daisy 1053
Outline 1035
French knot 501 (wrap twice)
Fly 416
Satin ① S106
413
Fishbone 2072
Outline 2072
411
Outline of legs and back: Outline 416
Bird is the same as motif 207

Long + short 5205 501 752
Fly ①416
Satin ①416

Outline 603
Fill with outline 603

214

Bird is the same as motif 207
Chain 736
Chain 390
Chain 413
Overlap sections of straight stitches ③273
Letters: Couching ②416 secured with ①416
French knot ①800 (wrap twice) on top of satin ①416
Satin 413
413
Back ①413
1035
Fly 413

Overlap sections of straight stitches ③653
Outline 411

215

Fill with outline 736
416

■ Fill the cat fur and bird feathers with short straight stitches unless otherwise noted. ■ Cat whiskers are straight stitch ①416 and mouths are outline stitch ②416.

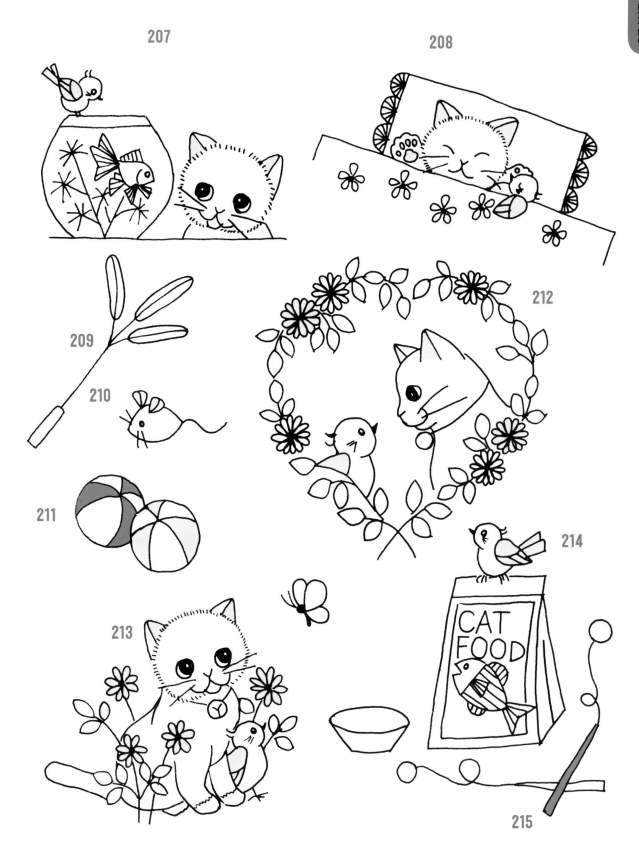

207

208

209

210

211

212

213

214

215

FOLK CATS

photos: pages 28–29

■ ◯ = Number of strands (use 2 strands unless otherwise noted) ■ # = Color number • Outline each motif with back-stitch 415 unless otherwise noted. *(continued on next page)*

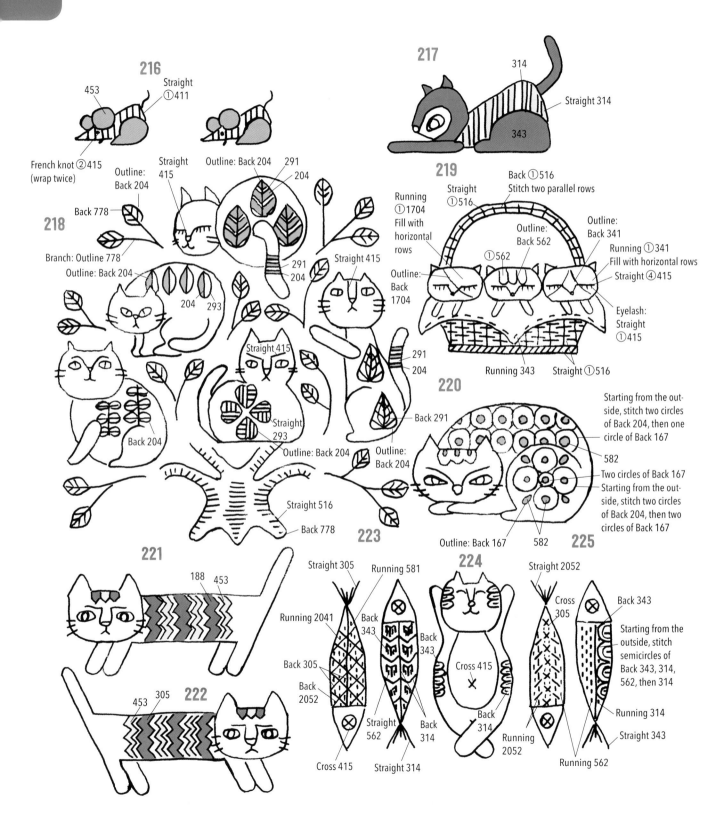

216
453
Straight ①411
French knot ②415 (wrap twice)
Outline: Back 204
Straight 415
Back 778

217
314
Straight 314
343

218
Branch: Outline 778
Outline: Back 204
204 293
Back 204
Outline: Back 204
291 204
Straight 415
Straight 293
Straight 415
Outline: Back 204
Straight 516
Back 778

Outline: Back 204
291 204
Straight 415
Outline: Back 204
291 204
Back 291
Outline: Back 204

219
Running ①1704 Fill with horizontal rows
Straight ①516
Back ①516 Stitch two parallel rows
Outline: Back 562
①562
Outline: Back 341
Running ①341 Fill with horizontal rows
Straight ④415
Eyelash: Straight ①415
Outline: Back 1704
Running 343
Straight ①516

220
Starting from the outside, stitch two circles of Back 204, then one circle of Back 167
582
Two circles of Back 167
Starting from the outside, stitch two circles of Back 204, then two circles of Back 167
Outline: Back 167
582

223

221
188 453

222
453 305

224
Straight 305
Running 581
Running 2041
Back 343
Back 305
Back 2052
Back 343
Back 314
Straight 562
Cross 415
Straight 314
Cross 415
Back 314
Cross 415
Running 2052

225
Straight 2052
Cross 305
Back 343
Starting from the outside, stitch semicircles of Back 343, 314, 562, then 314
Running 314
Straight 343
Running 562

■ Fill each motif with satin stitch unless otherwise noted. ■ Eyes are outlined with backstitch ②415 and pupils are satin stitch ②415 unless otherwise noted. ■ Noses are satin stitch ②415. ■ Whiskers are straight stitch 415.

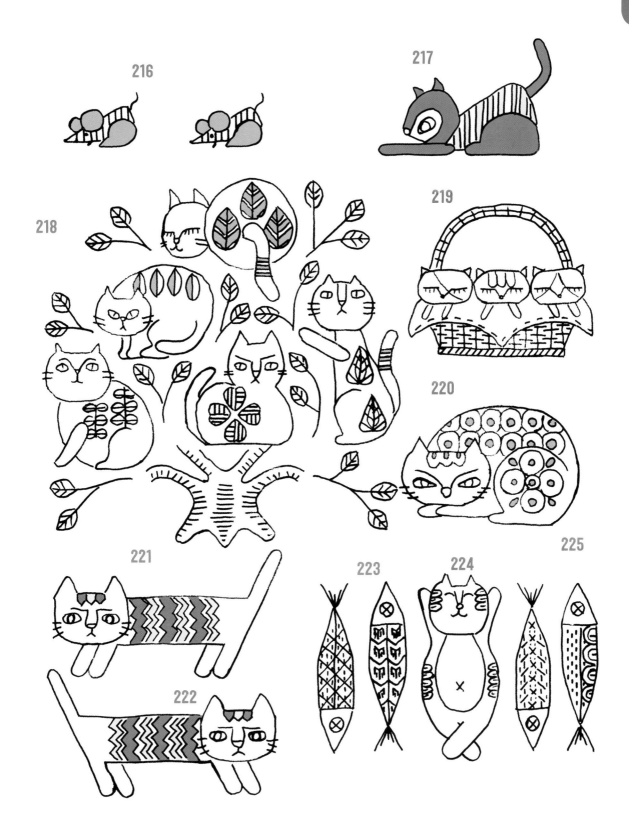

216

217

218

219

220

221

222

223

224

225

■ ○ = Number of strands (use 2 strands unless otherwise noted) ■ # = Color number ■ Outline each motif with backstitch 415 unless otherwise noted. ■ Fill each motif with satin stitch unless otherwise noted. ■ Eyes are outlined with backstitch ②415 and pupils are satin stitch ②415 unless otherwise noted. ■ Noses are satin stitch ②415. ■ Whiskers are straight stitch 415.

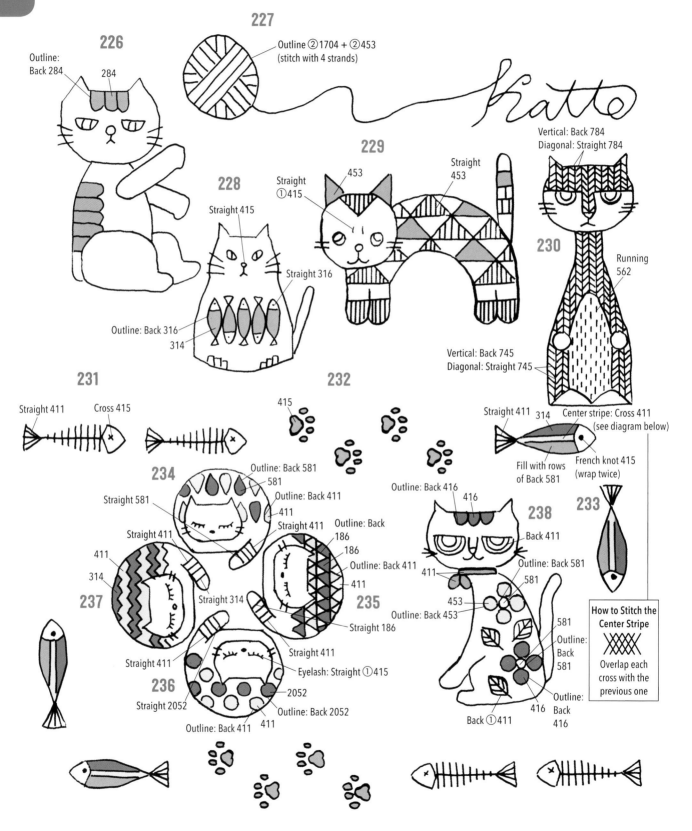

226
Outline:
Back 284
284

227
Outline ②1704 + ②453
(stitch with 4 strands)

Katto

228
Straight 415
Straight 316
Outline: Back 316
314

229
Straight
①415
453
Straight
453

230
Vertical: Back 784
Diagonal: Straight 784
Running
562
Vertical: Back 745
Diagonal: Straight 745

231
Straight 411 Cross 415

232
415

Straight 411 314
Center stripe: Cross 411
(see diagram below)
Fill with rows
of Back 581 French knot 415
(wrap twice)

233

Outline: Back 416
416

238
Back 411
Outline: Back 581
581
Outline: Back 453
453
581
Outline:
Back
581
416 Outline:
Back
416
Back ①411

234
Outline: Back 581
581
Outline: Back 411
411
Straight 581
Straight 411
Straight 411
411
314
Straight 314

235
Outline: Back
186
186
Outline: Back 411
411
Straight 186

237

236
Straight 411
Eyelash: Straight ①415
2052
Straight 2052
411
Outline: Back 411 411
Outline: Back 2052

How to Stitch the Center Stripe
Overlap each cross with the previous one

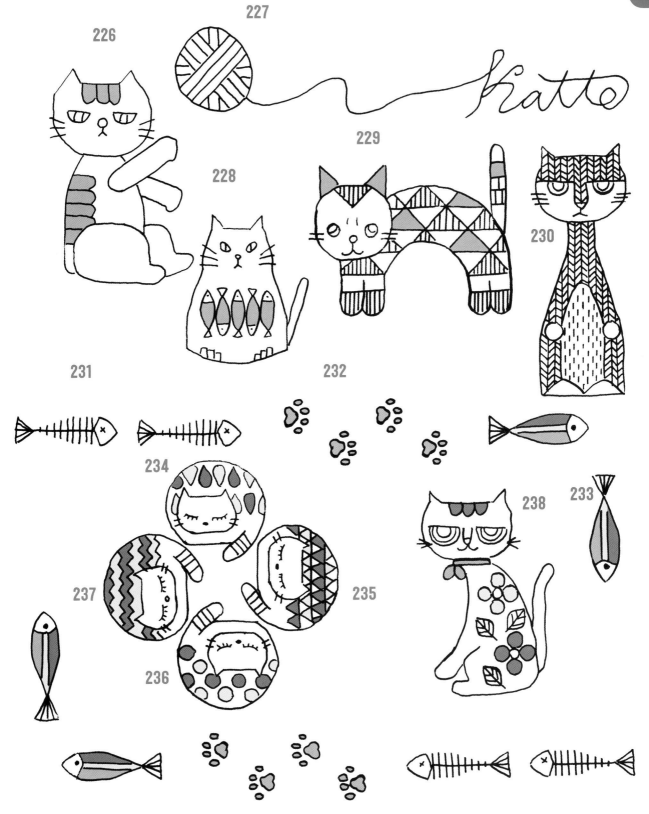

226

227

228

229

230

231

232

233

234

235

236

237

238

katto

ALPHA-CATS

photos: pages 30–33

■ ○ = Number of strands (use 1 strand unless otherwise noted) ■ # = Color number ■ All letters are outline stitch ②1906. (continued on next page)

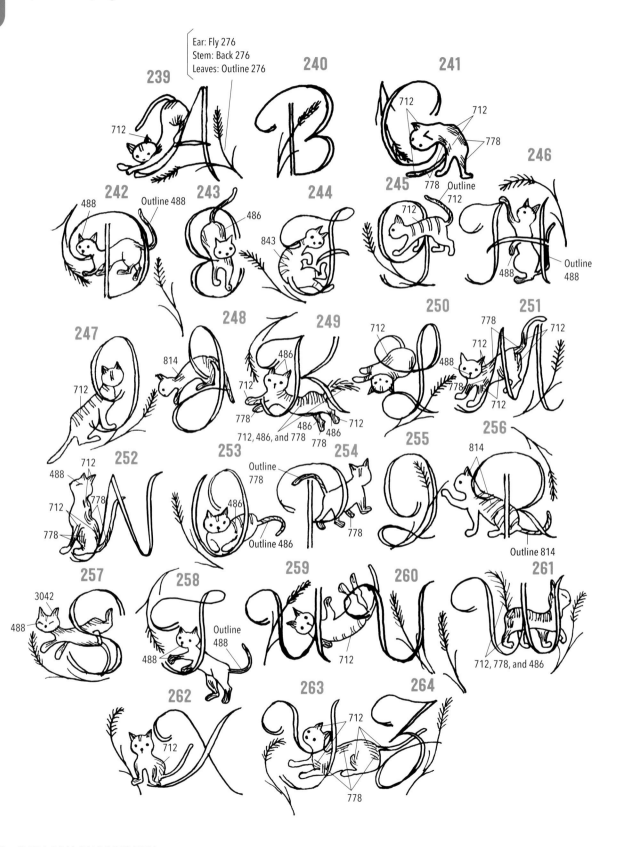

239 — Ear: Fly 276 / Stem: Back 276 / Leaves: Outline 276 / 712

240

241 — 712, 712, 778

245 — 778, Outline 712, 712

246

242 — 488

243 — Outline 488, 486

244 — 843

247 — 712, 814

248

249 — 486, 712, 778, 712, 486, 486, 778, 712, 486, and 778

250 — 712

251 — 778, 712, 488, 778, 712

252 — 712, 488, 712, 778, 778

253 — 486, Outline 486

254 — Outline 778, 778

255

256 — 814, Outline 814

257 — 3042, 488

258 — 488, Outline 488, 488

259 — 712

260

261 — 712, 778, and 486

262 — 712

263 — 712

264 — 778

■ All cat outlines are backstitch ①488. ■ Eyes and noses are French knot 488 unless otherwise noted. ■ Use straight stitch unless otherwise noted.

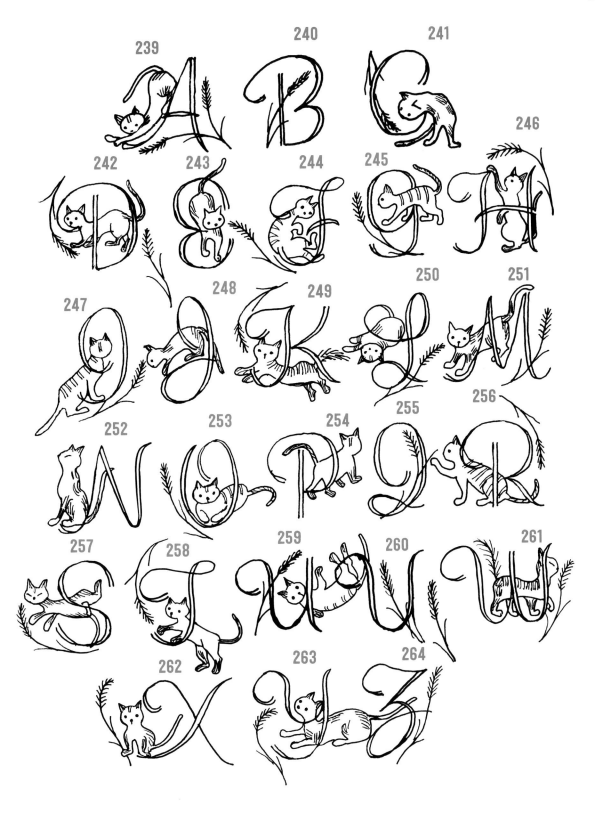

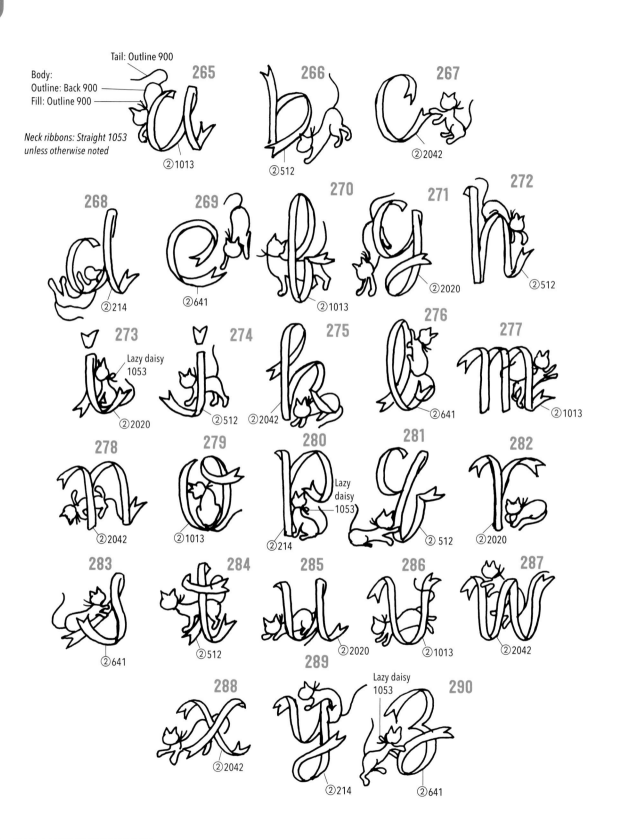

STITCH GUIDE

Tail: Outline 900

Body:
Outline: Back 900
Fill: Outline 900

Neck ribbons: Straight 1053 unless otherwise noted

265 ②1013

266 ②512

267 ②2042

268 ②214

269 ②641

270 ②1013

271 ②2020

272 ②512

273 Lazy daisy 1053 ②2020

274 ②512

275 ②2042

276 ②641

277 ②1013

278 ②2042

279 ②1013

280 Lazy daisy 1053 ②214

281 ②512

282 ②2020

283 ②641

284 ②512

285 ②2020

286 ②1013

287 ②2042

288 ②2042

289 Lazy daisy 1053 ②214

290 ②641

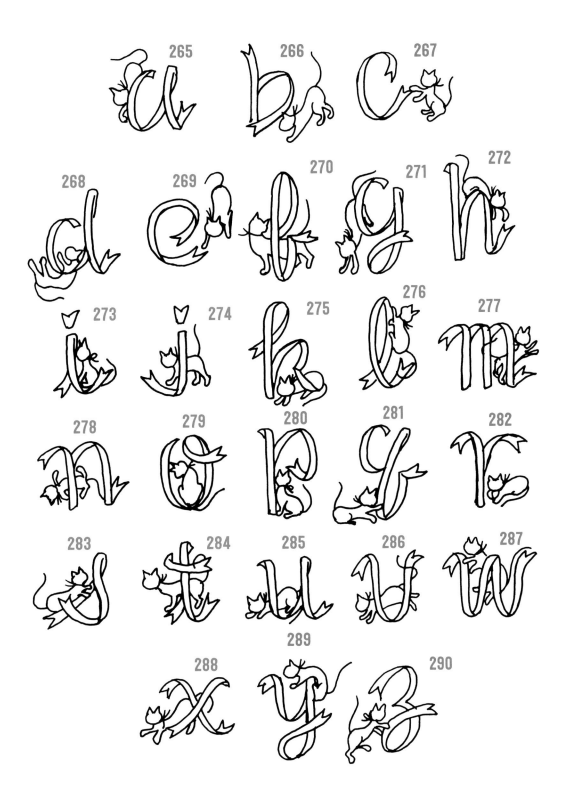

■ ◯ = Number of strands (use 1 strand unless otherwise noted) ■ # = Color number ■ All uppercase letters are filled with chain stitch ②2042. ■ All lowercase letters are outlined with chain stitch ②2041 or ②411 ■ Balls of yarn are outline stitch ②190. ■ Paw prints are satin stitch ②1600. *(continued on next page)*

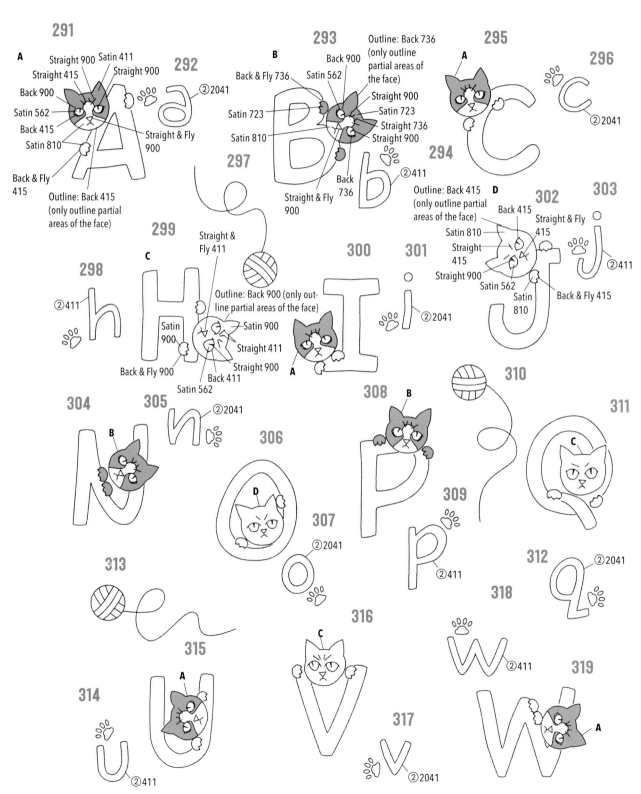

■ Noses and mouths are outlined with straight and fly stitch, and then filled with straight stitch. Refer to the individual diagrams for outline colors and the diagram below for fill colors.

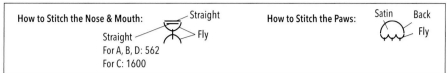

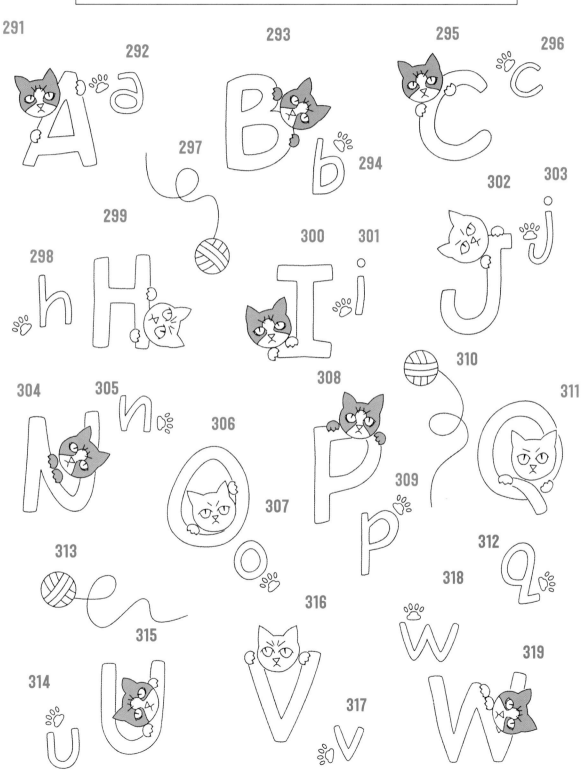

■ ◯ = Number of strands (use 1 strand unless otherwise noted) ■ # = Color number ■ All uppercase letters are filled with chain stitch ②2042. ■ All lowercase letters are outlined with chain stitch ②2041 or ②411 ■ Balls of yarn are outline stitch ②190. ■ Paw prints are satin stitch ②1600.

Refer to page 108 for instructions on stitching cat motifs A-D.

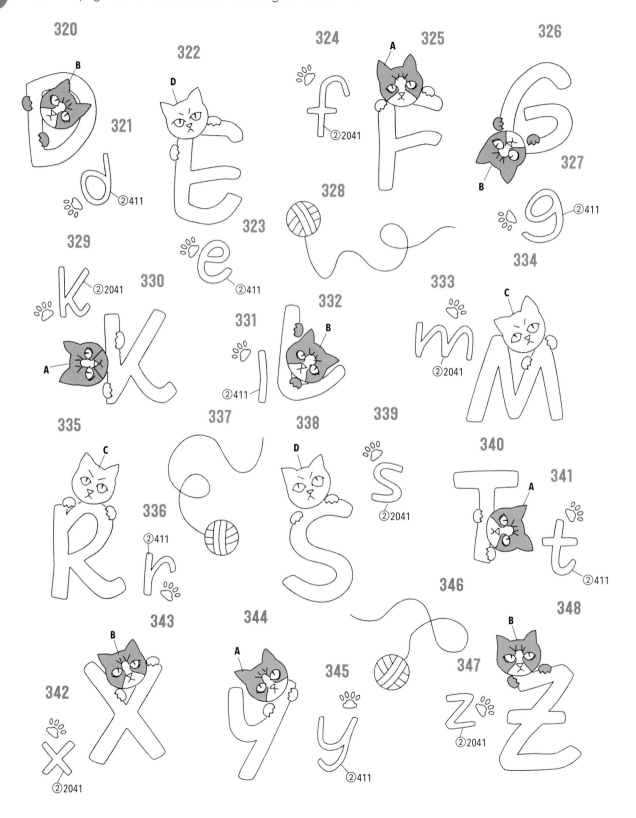

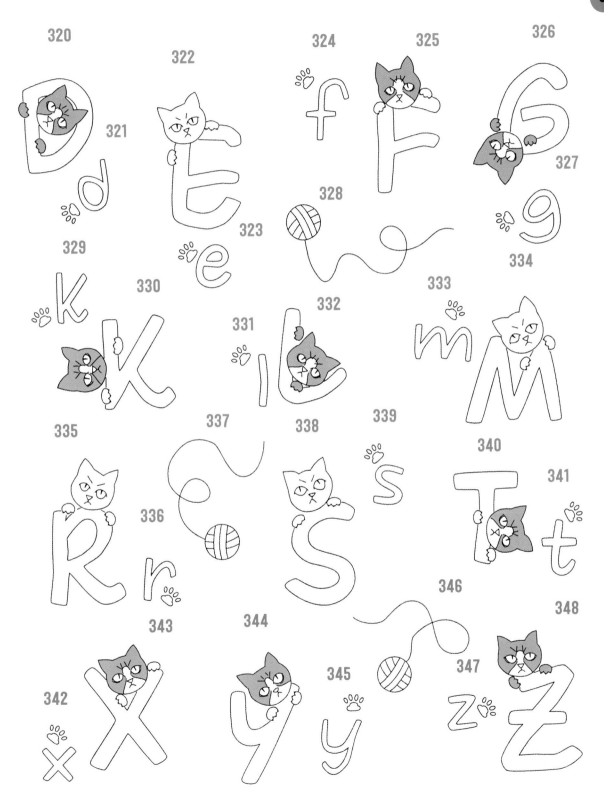

320
321
322
323
324
325
326
327
328
329
330
331
332
333
334
335
336
337
338
339
340
341
342
343
344
345
346
347
348

KITTY CORNERS

photos: pages 34–35

■ ○ = Number of strands (use 1 strand unless otherwise noted) ■ # = Color number ■ Use straight stitch unless otherwise noted.

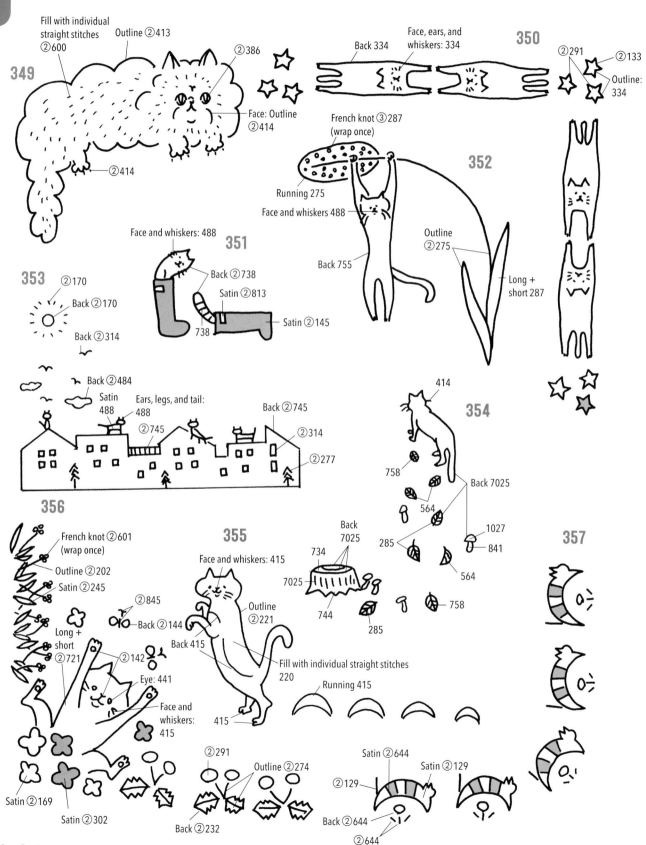

349
Fill with individual straight stitches ②600
Outline ②413
②386
Face: Outline ②414
②414

350
Back 334
Face, ears, and whiskers: 334
②291
②133
Outline: 334

352
French knot ③287 (wrap once)
Running 275
Face and whiskers 488
Back 755
Outline ②275
Long + short 287

351
Face and whiskers: 488
Back ②738
Satin ②813
738
Satin ②145

353
②170
Back ②170
Back ②314

356
Back ②484
Satin 488
Ears, legs, and tail: 488
②745
Back ②745
②314
②277

354
414
758
564
Back 7025
285
1027
841
564
758

355
Face and whiskers: 415
②845
Back ②144
Outline ②221
Back 415
Fill with individual straight stitches 220
Running 415
415

Back 7025
734
7025
744
285

French knot ②601 (wrap once)
Outline ②202
Satin ②245
Long + short ②721
②142
Eye: 441
Face and whiskers: 415
Satin ②169
Satin ②302
②291
Outline ②274
Back ②232

357

Satin ②644
Satin ②129
②129
Back ②644
②644

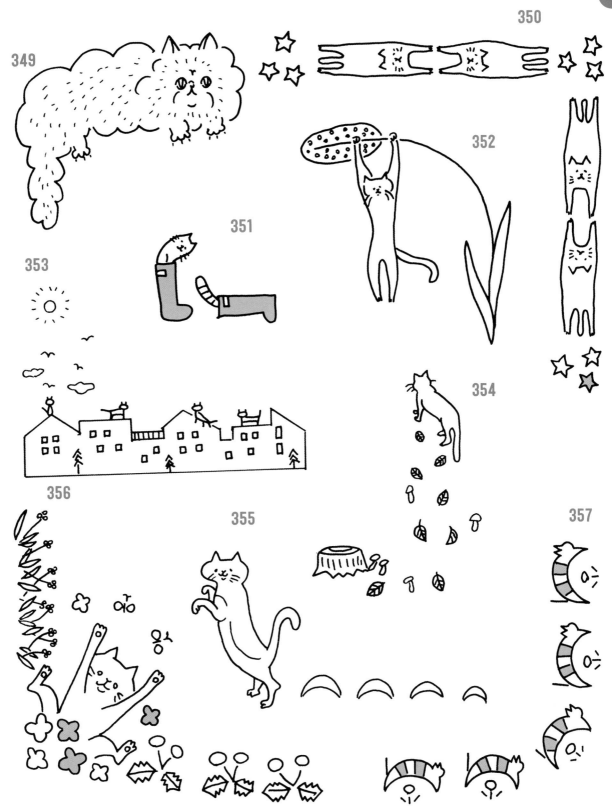

■ ◯ = Number of strands (use 1 strand unless otherwise noted) ■ # = Color number ■ Use straight stitch unless otherwise noted.

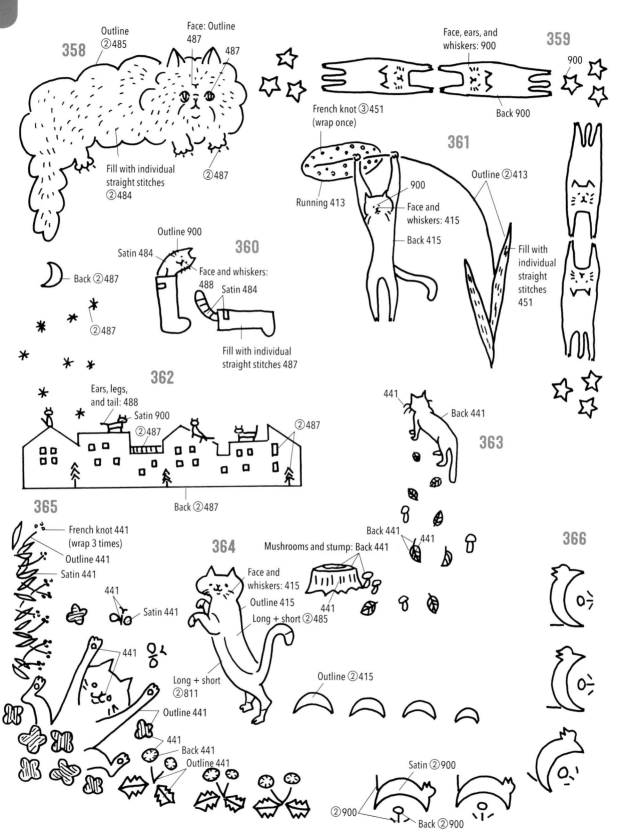

358
Outline ②485
Face: Outline 487
487
Fill with individual straight stitches ②484
②487

359
Face, ears, and whiskers: 900
900
Back 900

360
Outline 900
Satin 484
Back ②487
②487
Face and whiskers: 488
Satin 484
Fill with individual straight stitches 487

361
French knot ③451 (wrap once)
Running 413
900
Face and whiskers: 415
Back 415
Outline ②413
Fill with individual straight stitches 451

362
Ears, legs, and tail: 488
Satin 900
②487
②487

363
441
Back 441
441
Back 441
441

365
French knot 441 (wrap 3 times)
Outline 441
Satin 441
441
Satin 441
441
441
Back 441
Outline 441
Outline 441

364
Face and whiskers: 415
Outline 415
Long + short ②485
Mushrooms and stump: Back 441
441
Long + short ②811
Outline ②415
Outline ②415

366
Satin ②900
②900
Back ②900

Back ②487

358

359

361

360

362

363

365

364

366

KITTY BORDERS

photos: pages 36–37

■ ○ = Number of strands (use 1 strand unless otherwise noted) ■ # = Color number ■ Backstitch unless otherwise noted. ■ Wrap all French knots once.

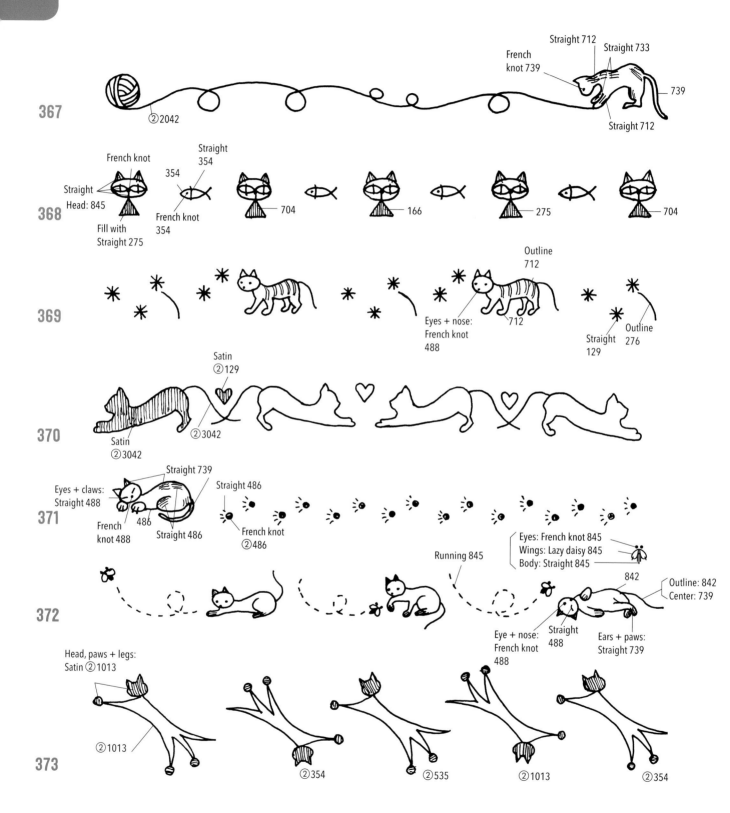

367 ②2042 — French knot 739 — Straight 712 — Straight 733 — 739 — Straight 712

368 Straight Head: 845 — French knot — Fill with Straight 275 — Straight 354 — French knot 354 — Straight 354 — 704 — 166 — 275 — 704

369 Eyes + nose: French knot 488 — Outline 712 — 712 — Straight 129 — Outline 276

370 Satin ②129 — Satin ②3042 — Satin ②3042

371 Eyes + claws: Straight 488 — Straight 739 — Straight 486 — French knot 488 — 486 — Straight 486 — French knot ②486 — Eyes: French knot 845 — Wings: Lazy daisy 845 — Body: Straight 845

372 Running 845 — Eye + nose: French knot 488 — Straight 488 — Ears + paws: Straight 739 — Outline: 842 — Center: 739

373 Head, paws + legs: Satin ②1013 — ②1013 — ②354 — ②535 — ②1013 — ②354

367

368

369

370

371

372

373

■ ○ = Number of strands (use 1 strand unless otherwise noted) ■ 488 = Color number for all designs ■ Backstitch unless otherwise noted. ■ Wrap all French knots once.

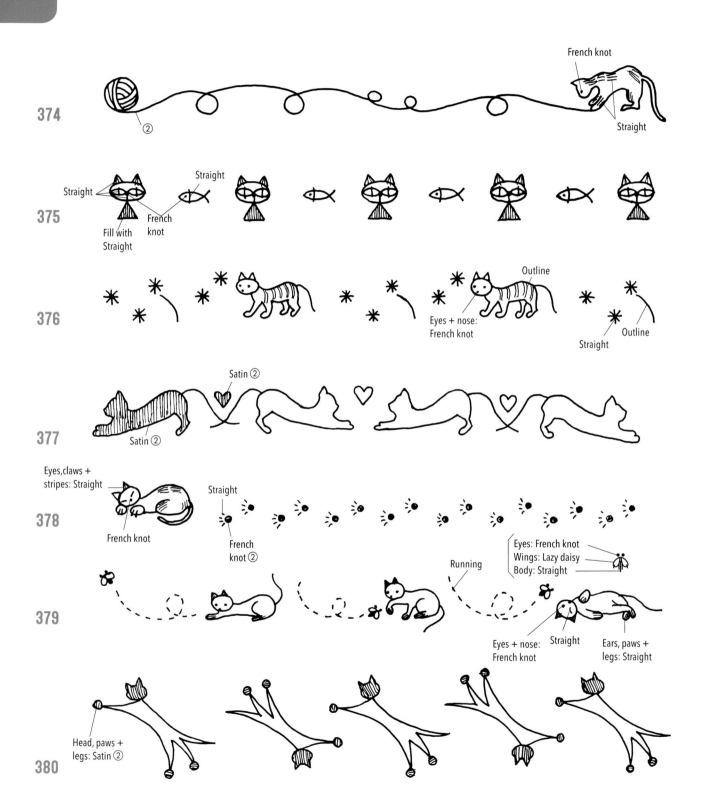

374 French knot / Straight / ②

375 Straight / Straight / French knot / Fill with Straight

376 Outline / Eyes + nose: French knot / Straight / Outline

377 Satin ② / Satin ②

378 Eyes, claws + stripes: Straight / French knot / Straight / French knot ②

379 Eyes: French knot / Wings: Lazy daisy / Body: Straight / Running / Eyes + nose: French knot / Straight / Ears, paws + legs: Straight

380 Head, paws + legs: Satin ②

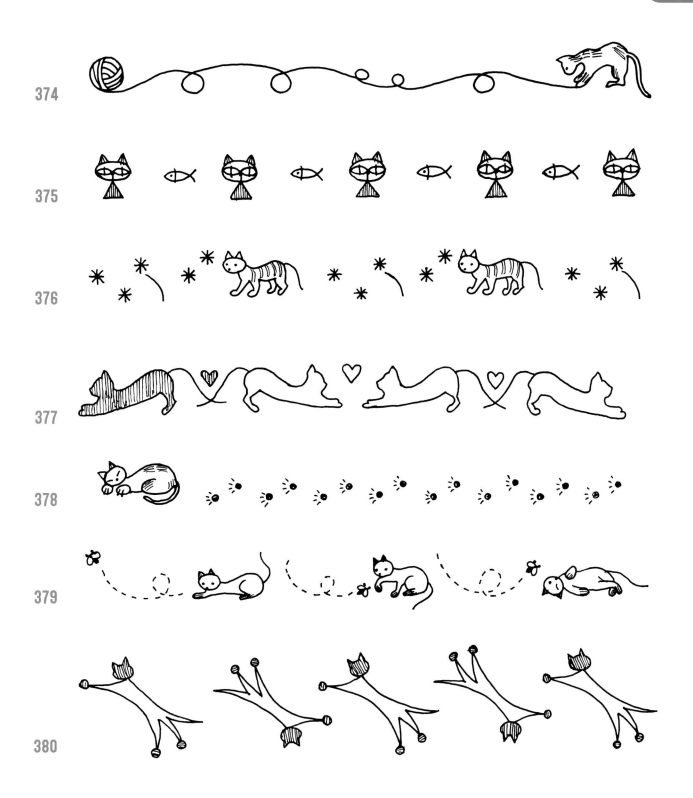

374

375

376

377

378

379

380

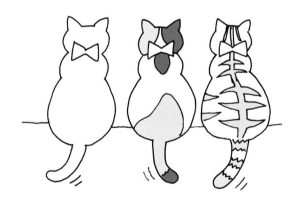

BYE BYE